Keepers of the Arts

Extraordinarily talented people.
Diverse, inspired cultures.
Tremendous creativity.

Artists have dramatically defined, redefined and
cataloged the progress of our earth's history.

Some push the boundaries of culture wide open,
broadening our horizons and painting our future.

Others work painstakingly to practice and perfect the
ancient arts — ensuring that our world's many and diverse
cultures will continue to thrive amidst modernity.

We know Picasso, Miró, Degas, da Vínci.

But who are Tinoco, Cardoso, Sandi and Mina?

They are among today's undiscovered masters.
They are in diverse lands, long isolated by time, distance
and geography.
They are inspired by the rich traditions of their heritage.
They are impassioned by the hope that their creativity may
soon be appreciated far beyond their borders.

They are the *Keepers of the Arts*.

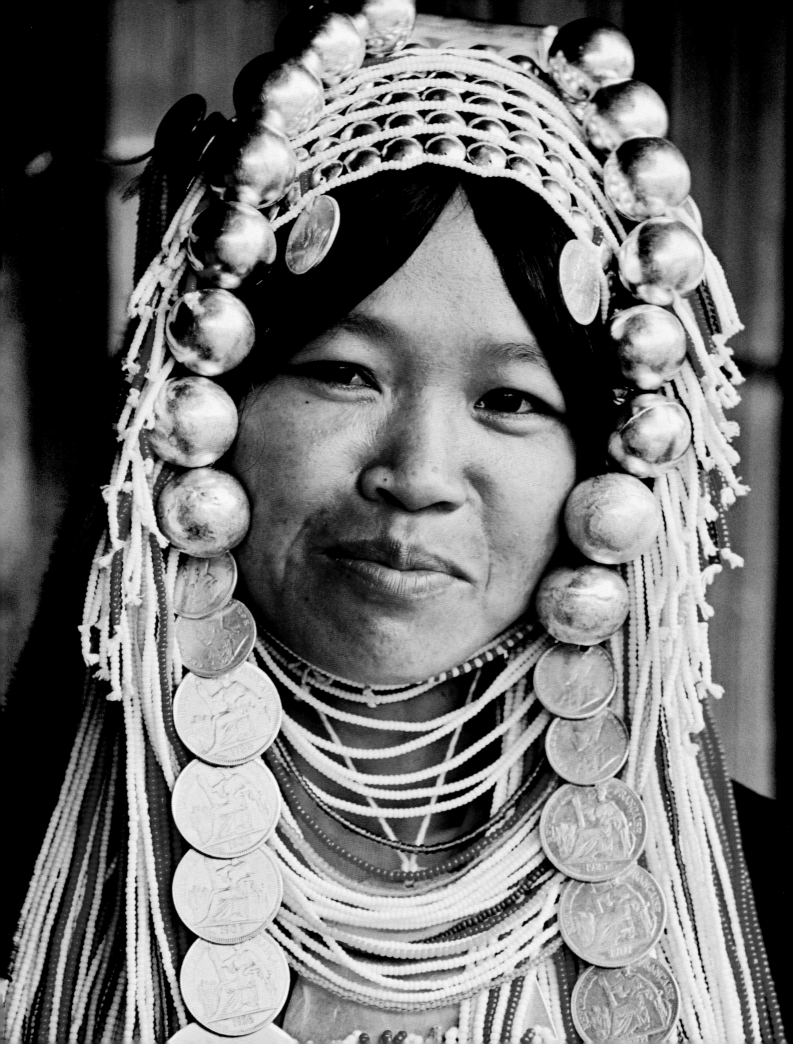

Keepers
of the Arts

NOVICA

With special thanks to
Michael Burns, Theresa Stone Pan, Doug Stern
and Kurt Engelhorn & our friends at Foursome

Published by

Novica
11835 West Olympic Boulevard, Suite 750E
Los Angeles, California 90064 USA
On the Web at www.Novica.com
(877) 266-8422

Production, Design, Editorial

Catherine Ryan, text author and principal photographer
John Buse, design and production artist
J.J. McCoy, editor
Marcel Honoré, assistant editor
Marissa Muñoz, researcher
Andrew Crocker, researcher
Debora Mondellini, translator
Rick Godnick, translator
Angie Sciarappa at Richard Photo Lab, scans
Vito Badalamenti at Overseas Printing Corporation, printing

Keepers of the Arts

Cover painting: "Nark in the Circle" by Lipikorn Makaew, Thailand
(courtesy private collection of Frances Hoffman).

"Keepers of the Arts" poem by Catherine Ryan

ISBN 0-9724791-0-4

Printed in Korea

Contents

The artists and artisans profiled in *Keepers of the Arts* can be
found on a special landing page at www.novica.com/keepers

Life on the Road

There are so many things in this wonderful world of ours to see, to learn, to feel, to try. I have the good fortune to travel continuously on behalf of Novica, experiencing the diverse richness of the earth's many cultures. I never tire of meeting new people and learning the intricate details of so many fascinating and ancient cultures.

As I have always believed in dreams — and continue to enjoy change — it was not a difficult decision to leave all my former activities and join this brilliant project. Novica provides a way for me to continue helping people; but this time, instead of solving problems, I am able to offer opportunities. Novica serves as an international marketplace where artists who never previously earned fair market prices for their talents can now showcase their traditional cultures and products directly to an enthusiastic worldwide market.

It is very exciting to see the impact we are having on the lives of thousands of artists; not just the 1,800 master artists currently profiled on the Web site, but also the assistants many of these artists have been able to hire as their businesses have grown.

We now have many offices around the world, staffed with truly outstanding human beings — always locals (experts in each region's arts and culture) and always individuals who believe strongly in our mission and our dreams. All of us together are honored to have created and facilitated a new kind of world marketplace focusing on the international recognition of extraordinary talent.

It is a great pleasure to help introduce our customers to other cultures and to read the testimonials they leave online, thanking us for our mission and explaining how purchasing through Novica turns out to be an extraordinary, unexpected cultural experience. I also enjoy revisiting artists who have become successful through Novica. As the artists become successful and recognized in their communities, their children and other young people begin to have a new respect toward traditional cultures and skills. All of this is very exciting, and it is rewarding to hear each new story of how Novica is changing lives around the world. That is what counts in life.

Through Novica, we hope to help demonstrate that it is possible to turn socially responsible ideals into

a successful business, significantly helping people all over the world. While "anonymous commerce" has become a way of life in the modern world, we're setting out to change that — by helping to bring producers and consumers back together again. Thanks to the Internet, direct and personal commerce is again a financially feasible way of doing business — a tremendous breakthrough, and we're very excited to be a part of it.

— Armenia Nercessian de Oliveira
Cofounder and President, Novica

Prior to cofounding Novica, Armenia Nercessian de Oliveira served as a United Nations officer working to resolve conflicts and defend human rights in war-torn countries around the world. As Novica's president of international operations, Armenia lives on the road, spearheading development of regional offices worldwide. She has spent time in 52 countries and is fluent in many languages.

Building a Revolution

"You're going to do what???"

"We're going to set up offices around the world."

"Offices around the world? Why? How? Why don't you just send buyers out to purchase items and warehouse them in the United States? That's the way it has always been done."

"That's exactly what we want to change. We want to build an entirely new system to connect artists directly with collectors worldwide. We want to build a revolution."

"Build a revolution? Ha! Well, good luck. If you ever get past the incorporation and establishment of offices overseas, try figuring out a way to handle the logistics and international fulfillment."

But build we did. We had passion. We had conviction. We had a strong sense of mission. And we had a powerful international network of extraordinary people with a wide range of skills, who all came together at the right time and in all the right places. That was the beginning of Novica.

The Early Days

Leaving behind jobs around the world, our headquarters team gathered in a Los Angeles basement and began working day and night. For more than a year, we built the back-end systems that would soon support the works of hundreds of artists and enable the shipment of thousands of orders to customers around the world. At the same time, Armenia Nercessian de Oliveira and the international team were actively setting up our first four international offices.

At Novica's inception, the connections we had made at Stanford University proved tremendously helpful — many of us had met there as students in the early '90s when we first began formulating the concept behind Novica. Also, contacts made through Armenia's two decades of international work with the United Nations proved invaluable. Moreover, many of us had friends and family in the initial target regions. So, based on our key international contacts, and our friends and family around the world, we had the beginning of an international team singularly focused on building a new system to empower artisans worldwide.

Aiming to launch to the public in mid-1999, we knew we needed to cover at least two continents to be able to provide artists and customers with a substantial initiative. The pressure was on as we neared our own "impossible" deadlines. Midnight conference calls, last-minute trips to Ghana and Peru, fast-track legal registrations with local governments — fueled by case after case of Brazilian Guarana soda, we kept at it and hit our deadline: Novica's Web site went live on May 20, 1999!

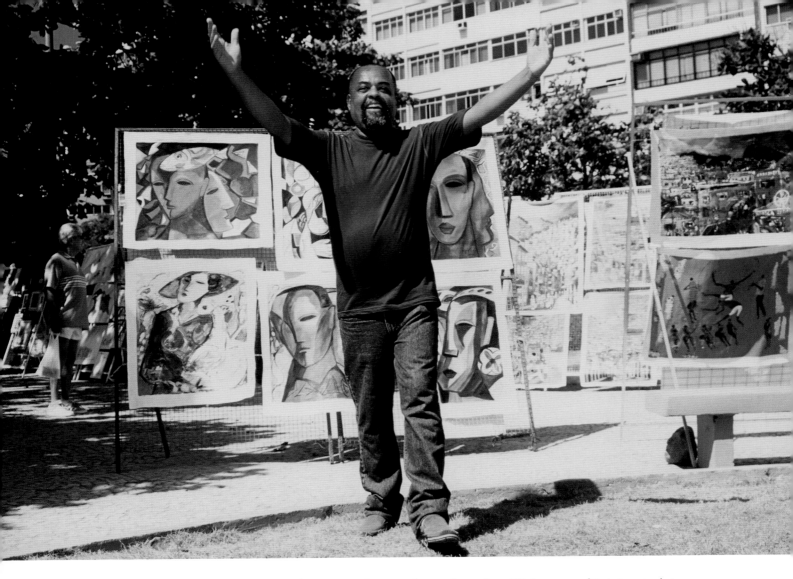

Brazilian artist Ney Cardoso, pictured here at the Ipanema Art Fair, was a skeptic at first — but quickly became one of Novica's most ardent supporters. He has developed a following of serious collectors in Paris and New York. Cardoso says the Internet has changed his life.

Toasting the event in Los Angeles and in our first four regional offices — in Brazil, the Andes, Central America and West Africa — we relaxed for a few days, and then immediately set out to recruit more artists and open more offices.

Direct to Artists

"Wait a minute. Let me try to understand. You want to photograph my products, tell my story, sell my products — and you aren't charging me anything upfront? There must be a catch."

There was no catch. But it was difficult to convince artists in those early days — they were so used to being taken advantage of that they viewed the goodwill behind Novica with distrust.

Artists Ney Cardoso and Luiz Antonio would lean back and laugh at Fabio Nercessian, the founder of Novica Brazil, when he made his weekly appearance at the Ipanema Art Fair in Rio to try to recruit painters.

"Hey guys," Luiz Antonio would shout out to his fellow

artists, "here comes the fancy photographer again to waste your time." Fabio silently accepted the abuse, meanwhile pleading with us at headquarters to hurry up and launch the site — his reputation was at stake!

For more than a month, Fabio continued to revisit the painters, photograph their one-of-a-kind paintings, and try to explain the Novica system — before the Web site was even live.

Then, one day, Fabio arrived at the art fair with an enormous smile. Novica had just launched, and already more than 20 paintings had sold. Fabio walked over to his early believers, beaming, and paid them for their works. The guffaws from doubters immediately ceased. All the artists suddenly surrounded Fabio: "Hey, Fabio, buddy... why don't you come over here and take some pictures of my paintings?!"

When Fabio arrived at the Novica Rio office the next morning, 15 artists were lined up outside — including Ney Cardoso — carrying with them their latest and greatest paintings ready to be photographed, reviewed and written up for the Web site.

The sudden buzz of Novica's innovative new system traveled fast in the artistic community and helped to recruit new artists. Artists told other artists, who told other artists....

With that, the Novica system was born. Securing direct and ongoing relationships across continents with thousands of artists was finally possible.

The Infrastructure

When a sale is made, each artwork is shipped directly to the customer from the country of origin. Purchase a painting from Lipikorn Makaew, in Thailand, and we handle all aspects of the sale, carefully packing the painting and shipping it to your doorstep.

One of the key elements to establishing the Novica international infrastructure was the development of a method to ship directly from our regional offices to customers at low shipping rates — while still retaining precise tracking capabilities.

Cofounders Andrew Milk, Novica's COO and Charles Hachtmann-Yang, Novica's CTO, were the primary developers of Novica's patents-pending logistics systems and procedures. Novica's Director of Logistics, Chris Floersch, a licensed U.S. customs broker, uses the system to oversee the seamless movement of shipments from around the world direct to each customer's doorstep.

> ## "We are not here to buy 50 or 100 pieces and then disappear until next year..."

... Novica Mexico Founder and National Representative José Cervantes would say to artists shortly after leaving his job with the Boston Consulting Group to establish the office out of his grandmother's garage. "We are here to build a long-term relationship with you. We want to know your story. We want to know why you do what you do. And, if things work out, you will sell five or 10 pieces every week, week after week after week."

Now, the Novica Mexico office works with more than 300 artists and is located in a 15,000-square foot facility near Guadalajara.

In Novica's early days, a mask by master carver I Nyoman Subrata in Bali might have cost a customer $40 to ship to the United States; now the same purchase costs only $7 to ship.

People always ask how we move so many different types of items around the world at such low costs. The economics are simple. Sending a small package from one of our regions to the U.S. might cost $20 per kilo. However, if you send 50 kilos, you pay less per kilo; if you send 500 kilos, then you pay much, much less.

Our biggest concern in the early days was how to create enough volume so that the shipping costs would not immediately bury us. Luckily, the business grew rapidly, we were blessed by extensive media coverage, and we soon signed an important strategic partnership with the National Geographic Society. Suddenly, we were doing enough volume from each region to secure steep shipping discounts into the U.S., making it possible for us to offer shipping rates as low as $5 per kilo.

Over the past few years, Novica has been sending consolidated shipments from each of its international regions every seven to 12 days into the U.S. — these are consolidations of all the items newly purchased by individual Novica customers. The shipments from Asia clear customs through Los Angeles, the shipments from South America and Africa clear customs through Miami, and orders from Mexico are truck-shipped through Laredo, Texas. After the consolidated shipments clear customs, the individual boxes waiting within are forwarded onward, directly to customers.

Perhaps the greatest challenge in building the system was figuring out how to get so many different types of items to clear U.S. customs in an efficient manner. In one consolidated shipment from Bali, there might be 1,000 different items, spanning 100 different customs classifications, and requiring more than 10 different export visas.

The secret? Every single item receives its designated Harmonized Tariff System classification before it even goes live on the Novica Web site. This way, all of the order lists and customs documents are pre-coded and

organized by customs classification when the regional logistics managers print them out — a process that would take days to prepare manually if not for Novica's patent-pending processes.

Although we ship to customers worldwide, Novica currently offers consolidated services (the inexpensive, normal shipping option) only to the continental U.S. In the years to come, as volume increases into Europe and other consumer markets, we look forward to introducing this less expensive option to more customers around the world.

"I want to make the finest art."

When we first began, we would never have imagined that, of the many advantages that Novica presents to artisans, the single biggest advantage would be the ability to make it financially feasible for artists to use better materials and concentrate on creating ever-more magnificent works of art.

Time and time again, in our travels and at our regional offices, artists tell us that they are thankful for the Novica system. Now they can finally focus on making higher-quality items with more detail, and in turn earn a higher price for their work — instead of being asked to produce large quantities of items as cheaply as possible.

Artists inevitably tell us that they were never satisfied with the traditional system of trade, in which middlemen ask them to use lower-quality materials and less detailing to produce items faster and cheaper for one-time quantity buys.

The Novica system is built around a basic concept: Create an efficient market by reducing the multiple layers of middlemen. By doing so, the Novica system allows for artisans to make more and collectors to pay less.

In the traditional system, a fine Peruvian tapestry costing 200 soles (approximately $60) typically goes through five intermediaries and multiple layers of inventory risk before retailing in the U.S. for $1,000 to $3,000. In the Novica system, the weavers set their prices above local market prices and collectors can purchase the tapestries for $150 to $300, well below standard international retail.

Biographies and photographs of each artisan are included on the Novica Web site along with detailed information on each art object, enticing the viewer to learn about each work and the artist and culture behind it. Thus a vase purchased through the Web site is not just a vase, it is an elaborate conversation piece. An oil painting is not just exotic living room décor, but the vision of hope that came in a dream to paraplegic artist Pranote Wattanasawat. Even a handmade drum carries its story — made on a beach in West Africa by Joseph Aboagye, a man who says he loves to look out over the sea while he works, wondering who will next touch his latest creation, knowing the drum will travel to continents he may never see.

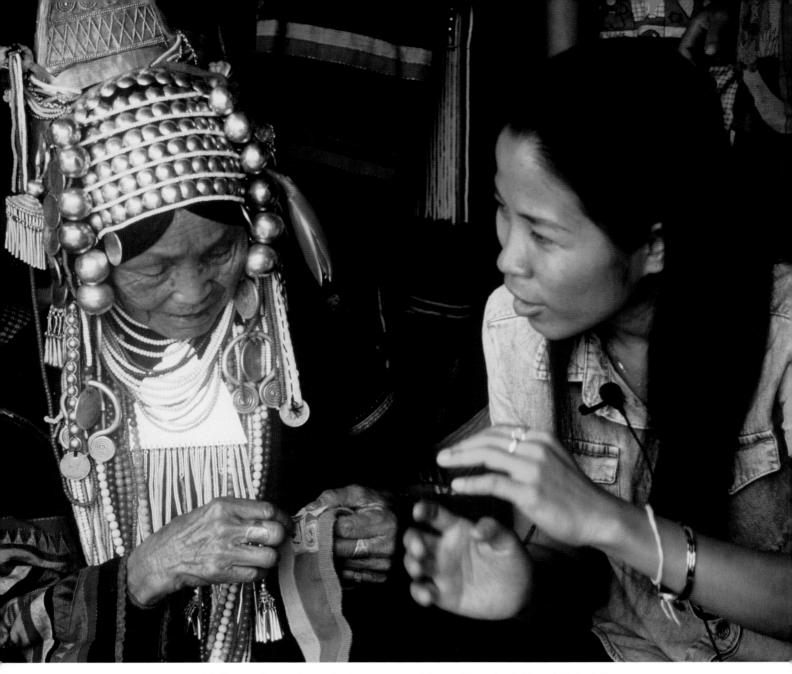

Aphi Mina, textile artist, discusses her latest creations with Pornpun Wunna, head of Novica's Thailand office.

Novica, meanwhile, encourages artists to perfect their craft, not simplify it.

At the center of Novica's operating philosophy is the belief that an artist's dream is to receive more value and recognition for their work over time, as they establish a name and build a following.

For this reason, our ongoing local relationships with artists are crucial. Artists bring their latest and greatest creations to our regional offices continually, and enjoy receiving ongoing feedback from the local Novica teams. Working with only the leading artisans in their respective fields, less experienced artisans strive to perfect their craft to be considered for representation by Novica.

This constant stream of high-quality items, we believe, is one of the reasons Novica and each of our participating artists receive such an extraordinarily high level of feedback, dedication and support from customers.

Striving continuously to exceed customer expectations and to ensure that every item is created and shipped with great care, we seek to develop a very real sentiment of connection between people.

And, at the heart of it all, we have been able to answer with a resounding "yes!" the most basic question that determines the success and survival of any new system: "Will customers return again?"

The Future...

With more than 1,800 artisans and artisan groups working with Novica, we currently impact approximately 10,000 artisans in aggregate, creating an impact community of artisans and family members totaling 50,000 people worldwide. This impact is significant, but for us it marks only the beginning.

Thinking long-term (10 to 20 years from now), what will happen to Novica? What will happen to our society's purchasing habits? Will more people seek to purchase directly from artisans? Will more people care about how their items are made, who made them, and under what conditions? Will direct-from-artisan sales eclipse the sales of a large retailer such as Pier 1 Imports, which sold more than $1 billion in products last year? All of us at Novica hope so.

Research, such as that conducted by Paul Ray, author of *The Cultural Creatives: How 50 Million People are*

Many Novica customers fit the Cultural Creatives* profile

- In 2000, Cultural Creatives represented 50 million people in the U.S. and 60 million people in Europe

- They represent the fastest growing segment of the U.S. population

- Are independent, innovative thinkers with a social conscience

- Are focused on environmental and cultural sustainability

- Enjoy travel and are interested in learning about other cultures

- Are avid readers and radio listeners, not necessarily TV watchers

- Are focused on values-based purchasing

- Think globally and act locally — they are typically involved in local community groups

- Their décor has meaning behind it, typically with original art on the walls and craft pieces around the house

The term "cultural creative" was coined by Paul Ray, a market researcher, cultural anthropologist and author of The Cultural Creatives: How 50 Million People Are Changing the World.

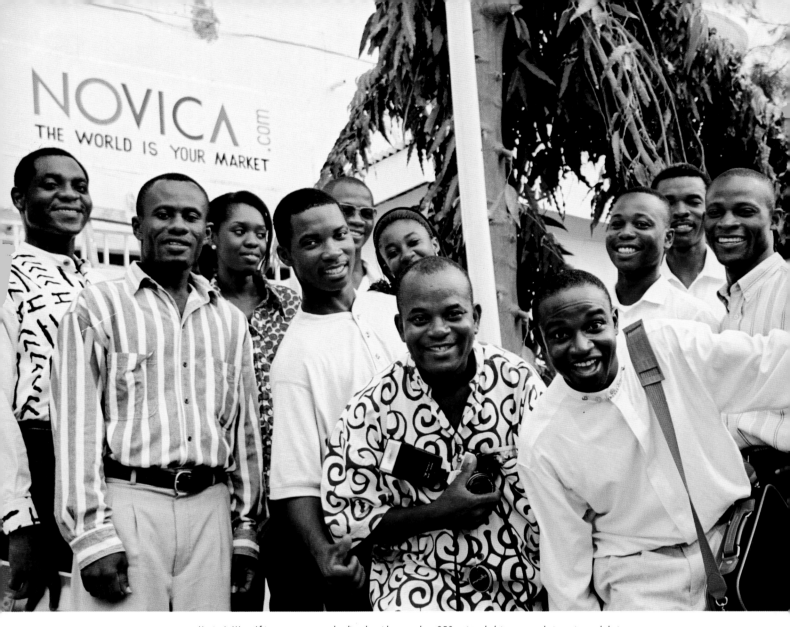

Novica's West Africa team now works directly with more than 250 artists, helping to get their stories and their artwork onto the Internet — and directly into the homes of appreciative customers worldwide.

Changing the World, shows that we are living a social phenomenon in the U.S. and Europe where consumers are aware of their purchasing power, and are actively seeking greater depth, meaning and information about the products they buy.

These social shifts, combined with the increasing speed and efficiencies provided by the Internet, all bode well for artisans and consumers worldwide.

We are honored to play a role in this important global development, and you can count on all of us at Novica to continue our commitment and efforts in the years to come.

There are so many people who deserve special thanks for their assistance, including the many members of our global team, our financial backers, our marketing and strategic partners, and — in particular — our dedicated customers who continue to bless Novica with

16

their repeat orders and their incredibly strong word of mouth. All of you have played such an important role, and without you, none of this would be possible.

Now we hope you'll sit back and join us for an adventure around the world, visiting just a few of the fascinating regions where Novica works with artists. We promise to introduce you to some tremendous artists, cultures, and one-of-a-kind personalities en route....

— Roberto Milk
Chief Executive Officer, Novica

Excerpt of Novica Public Policy Paper delivered to Mexican President Vicente Fox, *February 2001*

The construction of a system to link artisans with consumers has an array of benefits to your nation, including:

- Creating viable business opportunities and economic development for artisans and artisan communities

- Decreasing urban migration from rural areas and villages

- Creating positive public sentiment among artisan communities towards the Internet and the global market

- Facilitating Internet use among groups often disadvantaged by the "digital divide"

- Providing support for the arts

- Preserving traditional art forms

- Encouraging cultural travel and tourism

- Providing a platform for cultural, personal and artistic expression

- Bringing the artistic talents and the rich cultural heritage of your nation to the world

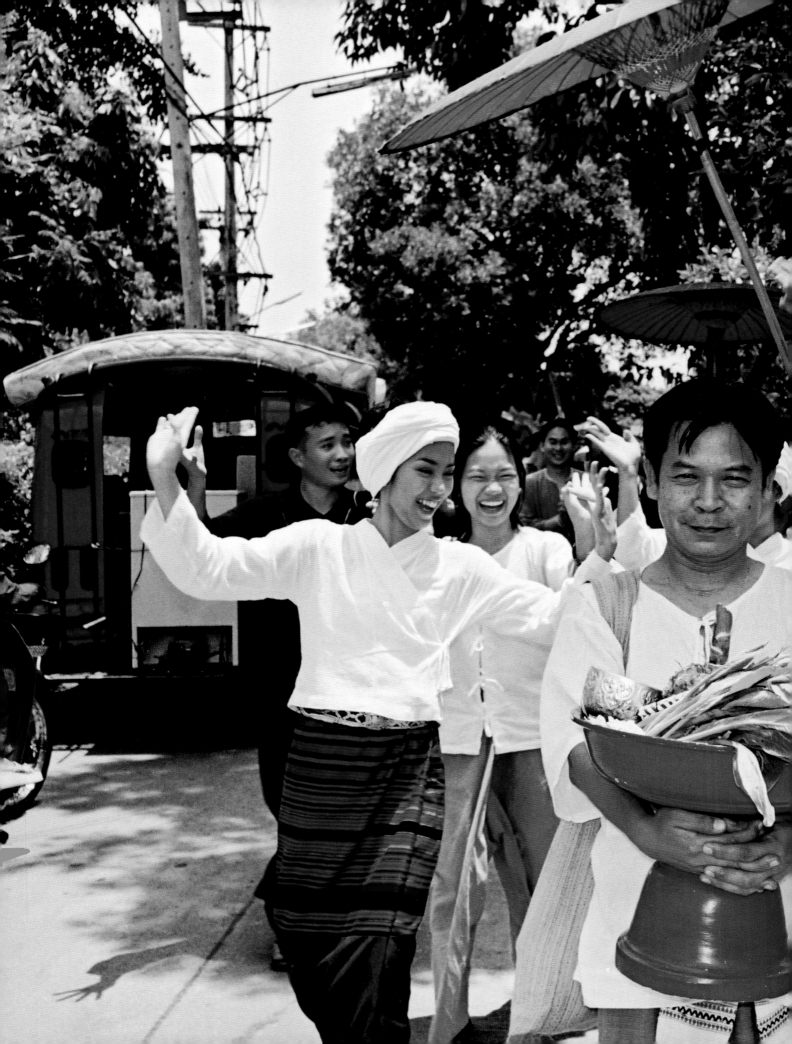

Asia

Life As Art

Off the beaten path in magical, mysterious Bali

entle laughter echoed across the valley early this morning, like the tiniest bells tinkling in the distance. Eyes still closed, I could visualize the Begawan villagers walking barefoot down the mountain to their ancient, sacred spring. There they would offer their daily ritual of flowers, incense and tropical fruits to the Hindu gods. In the steep canyon far below, a series of waterfalls cascaded into the raging Ayung River, the sounds of pounding water filtering up as barely a whisper at this awesome height.

Some of the world's finest resorts, surfing beaches and coastline can be found in Bali. Lesser known is the island's extraordinary interior and its peaceful, artistic culture. Here, life centers around the arts, performed in the spirit of a gentle, joyful, Balinese version of Hinduism. The Balinese have nurtured a distinct culture of kindness and openness that embraces outsiders while maintaining a steadfast reverence for its own rich and ancient traditions.

Perhaps the Balinese remain at peace because they live life in a constant state of revelry. On any given day, visitors are swept up in massive parades as entire villages flood out into the streets — both men and women dressed in sarongs of shimmering silk and gold, carrying generous pyramids of fruit, roast pig and other offerings balanced atop hundreds of dancing heads. Invariably, raucous gamelan orchestras follow the entourage in close step — a cacophony of sound that makes sense only here. The parades slowly wend their way to elaborate temple ceremonies, funeral pyre parties, shadow-puppet performances, toothfiling events, weddings and child-naming dinners that are the central events of the community.

Visitors who show an interest in Balinese culture are greatly appreciated by the locals, and are typically treated as guests of honor. During this latest visit, we participated in a constant stream of celebrations, the first held over dinner at the home of master woodcarver I Nyoman Subrata.

The evening was magical. We enjoyed a sumptuous feast, dining with our fingers, local style. Subrata's daughters and their friends — dressed in their finest red and gold silk — performed a series of traditional dance stories with fiery passion and grace. We were transported to what seemed to be another era; however, in Bali, this is daily life, where dramatic displays of traditional culture are not reserved solely for tourists but remain integral to the community.

Our questions about the dancers' luminous costumes led to a series of adventures that filled the days to follow. We drove from village to village with Ketut Kesuma Jaya (from Novica's Bali office) and three journalists who had arrived to interview Novica artists about their newfound success on the Internet.

In village after village, we were welcomed into the homes of one gracious family after another, meeting costumers, dance-crown makers and the renowned

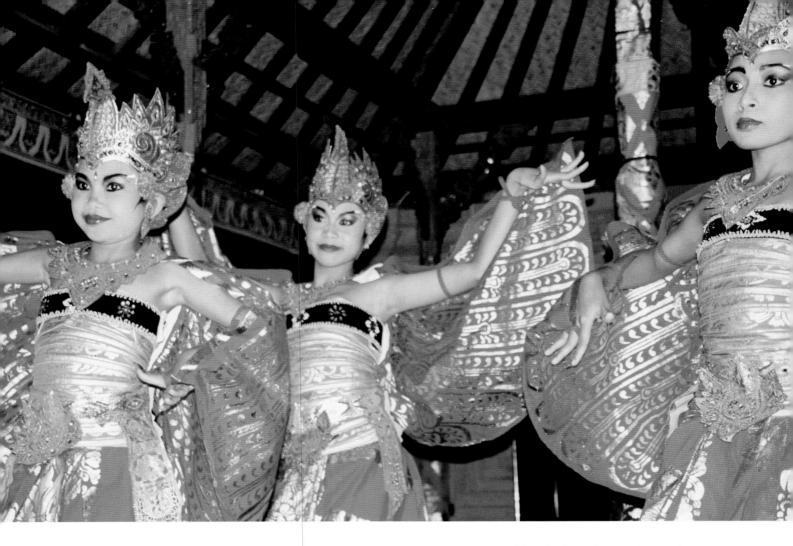

dance mask-maker, I Nyoman Setiawan.

We followed an unmarked, winding country lane to Setiawan's home, where Ketut pulled up to park beside a high stone wall. Ancient, lichen-covered masks guarded the front gate. Newer wooden masks hung from the rafters of a palm-thatched workroom inside.

The mask maker ushered us into his simple workshop with the dramatic flair of a great actor — transforming it with little more than a few gestures into a grand performance studio.

When the journalists had completed their interviews, Setiawan offered to demonstrate several of Bali's traditional dance sagas. A preeminent dancer in the region, Setiawan carries on a generations-old family tradition. While a full performance would include a dance troop and orchestra, for this private demonstra-

tion Setiawan would make do with just a few neighboring musicians to accompany him.

After hanging a glittering curtain in front of a dusty storage shelf, Setiawan sat on a stool and pulled the curtain closed in front of him. A few minutes sped by while he changed into costume. His feet, peeking out from below the curtain, soon began to tap in time with the building beat of the instruments.

Fists clenched, keeping the curtain closed, Setiawan's angry hands gradually began to part the silk, finally revealing a hideous face and a magnificent costume that slowly rose with the increasing drama of the music. A lengthy pantomime of pain, sadness and comedy built into ecstatic frenzy before slowing down again as the masked man retired to his stool. Gradually, he pulled the curtain closed.

In one fantastic drama after another, we witnessed a procession of faces and folklore woven into a magical evening — a masterful performance that should have been enjoyed by a thousand enraptured fans.

His face dripping with sweat, Setiawan removed his final mask. Relaxing against the wall of his studio, he explained that he blesses each mask in a special temple ceremony before using it for the first time.

"I offer gifts and my own secret words to the gods as part of the ceremony. More I cannot tell you," he explained. "The words I use each time must remain between me and my gods."

A rooster crowed and Setiawan's 5-year-old son walked tentatively into the workshop to show us a basket of fluffy, just-hatched chicks. Setiawan's children are learning to dance; they too will proudly carry on their family's ancient tradition.

The next evening we arrived in Ubud, Bali's central artists' colony, hoping to attend the town's popular shadow-puppet performance. Alas, we were too late to catch the show. Ketut offered instead to drive us the following day to the home of shadow-puppet maker I Wayan Mardika Bhuwana, who sells his beautifully ornate shadow puppets through Novica. This way we could meet a master puppeteer firsthand, Ketut said, and perhaps enjoy a private performance.

Bhuwana was working when we arrived, sketching a puppet figure onto rice paper. He showed us how he places a translucent sheet of rawhide over the finished sketch, then cuts into the rawhide, tracing the ornate images showing through from the rice paper. We watched a chiseled figure emerge. Next, he painted it with brilliant colors — intricate artistry generally overlooked by tourists who only see the puppets' shadows through the stage screen. Here in Bali, Bhuwana explained, spectators are welcome to visit backstage

during the performance to get a closer look at the puppets' fantastic craftsmanship and the puppeteers' masterful theatrics.

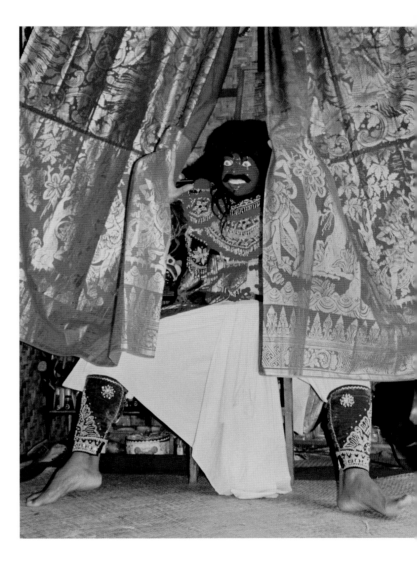

Bhuwana said he prays to the god Iswara and places offerings of egg, coconut and rice in his local temple and on stage before and after each show, to ensure a great performance and give thanks.

"It is told that Iswara performed a puppet show in heaven, and the gods watched him," Bhuwana explained. "That is why he is the god of the puppeteers."

Bhuwana explained that a complete, three-hour puppet show includes 100 characters, an orchestra and a phalanx of assistants. Most tourists watch an abbreviated show, while Balinese audiences sit raptly through a full performance uninterrupted by break or intermission.

With a twinkle in his eye, Bhuwana asked which version we would like to see, then laughed before we could answer. He would perform the abbreviated version, managing 20 characters, 20 voices and the traditional story lines with the help of just a few assistants.

Bhuwana's neighbors began to join us. A grandmother carried over a basket of exotic rambutan fruit for all to share. Others brought drinks and traditional sweets — sticky rice and coconut sugar baked in banana leaves.

We waited for nightfall. Then Bhuwana lit a torch to cast the shadows against the screen, and the puppets came to life. While I didn't understand the puppets' language (the characters spoke in an ancient version of Balinese that few locals still speak), the masterful theatrics were sufficient to draw us deep into the epic tale. Bhuwana spiced his performance with occasional splashes of sly English humor — jokingly flirting with the women and challenging the men in our small audience, a delightfully hospitable gesture surely meant to lure us further into the story.

We watched as the mythic lives of fearful adventurers, enchanted forests of talking trees, and wild animals unfolded on the flickering screen. Characters were transformed into undersea creatures, only to emerge again as birds in flight. Meanwhile, the gamelan musicians played frenetically to keep pace.

By the time the evening ended and the Balinese moon had moved far across the sky, we felt we knew well yet

another side of this fascinating culture. Bali is a land of endless discovery, perhaps best approached without an extensive agenda; adventures here inevitably unfold before you.

The next afternoon, driving along winding one-lane roads past towering volcanoes and picturesque rice paddies, we stopped at the open-air painting studio of I Wayan Rana, one of the finest traditional artists on the island. He was hard at work on his latest masterpiece when we arrived, painting a complex festival scene. He squinted to point out the central characters, minuscule images scattered amid a multitude of revelers. Rana's daughter arrived with refreshments — fresh, young coconuts brimming with sweet, cool nectar.

Rana laughingly recalled his first attempt to sell a painting, when he was still a teenager. Without money for a motorbike or taxi, a friend carried him on the back of a bicycle many miles to town, where a gallery owner had promised to sell his work. Halfway to their destination, Rana and his friend crashed — and Rana's prize painting was thrown facedown into the mud.

"I washed the painting in a stream, then laid it out flat in a rice field," Rana explained. "I sat there until late in the afternoon, waiting for the painting to dry. At the end of the day it looked new again, so I finally took it into the gallery to sell. The owner saw the painting and exclaimed over its beauty. But then he noticed a tear that I had overlooked. Nearly two months of work, gone; I couldn't forget the disaster for some time."

I noticed a few finely dressed villagers striding past the painter's studio, headed into town, carrying silver offering bowls and burning incense. I asked Rana if our visit was keeping him from village activities. He laughed, and said that our arrival

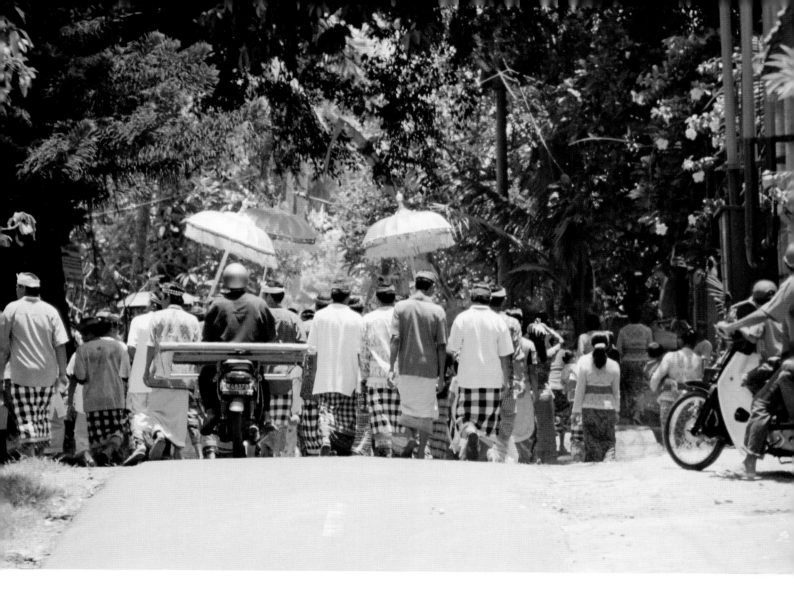

would likely coincide with a festivity no matter which day we chose. Then, as the Balinese do, he asked if we'd like to participate.

Rana's wife and daughter busied themselves dressing us in traditional temple clothes while he explained the details of what we were about to witness: an official coming-of-age "tooth-filing" ceremony that would last well into the night. The 2,000-year-old tradition would involve feasting, intense chanting, and purification ceremonies performed by one of Bali's highest Brahmin priestesses. The priestess would also file smooth the rough edges on the teeth of two local villagers — a teenage boy and girl — with particular attention given to smoothing their canine teeth.

Rana explained that for the Balinese, teeth symbolize anger, lust, greed and jealousy. It is believed that smoothing the teeth dispels the forces of evil and purifies the subject of animal-like features and behavior, adding to the physical and spiritual beauty of young Balinese as they transition from adolescence into adulthood.

Rana and his family graciously introduced us to their fellow villagers; many went out of their way to explain the intricacies of the unfolding events. The evening-long spectacle capped an extraordinary journey — visiting an enchanted island where unexpected adventures await around every bend.

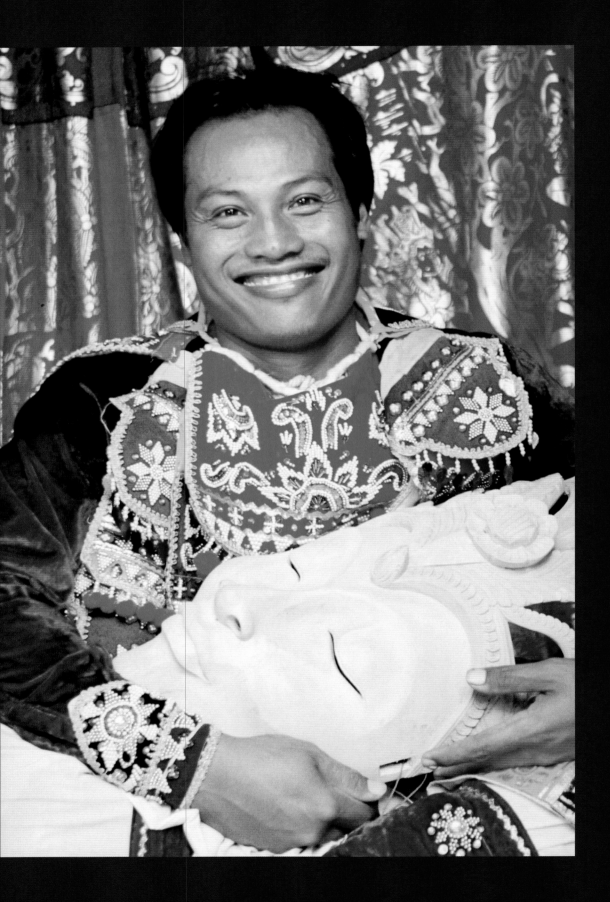

I Nyoman Setiawan

"Truthfully, my desire to make traditional masks is founded in my amazement at the beauty of these masks…"

"At the age of 15 I began learning to carve masks under the guidance of my father, a master mask-maker who was then already 65 years old. I began to apply myself seriously to mask-making at 20 years of age, using pule wood and experimenting with goatskin.

"My village, Lantangidung, happens to be the home of Sanggar Tari Topeng Regeg, a famous dance troupe. These dancers are in high demand, performing traditional dances such as the *arja, tari topeng,* and *sendratari* for religious ceremonies around Bali. Truthfully, my desire to make traditional masks is founded in my amazement at the beauty of these masks used by our famous dance troupe. I am also actively involved as a founding member of the *kecak* dance troupe in my village.

"I create more than 100 kinds of masks, mainly for sacred religious purposes but also for popular use. My modern designs, in particular, have become quite popular abroad. I hope that people the world over will appreciate the artistic value and hard work of my creations — and my ideas."

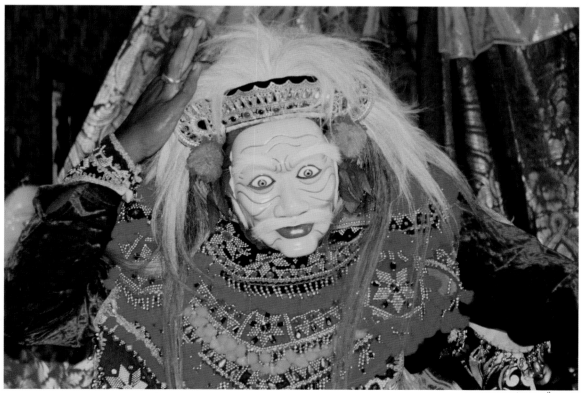

www.novica.com/keepers

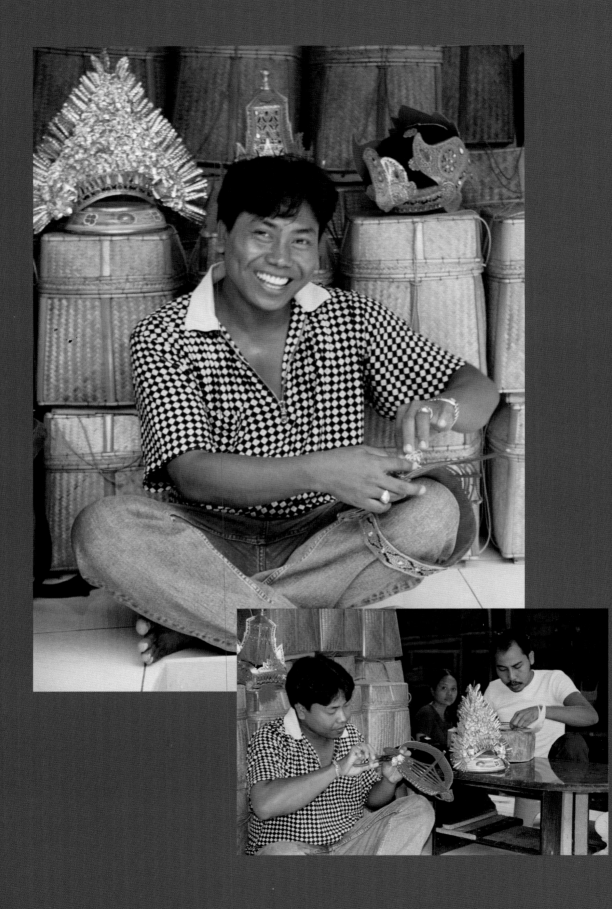

I Wayan Balik Maharsa

"Dance crowns had become so expensive that I couldn't afford to buy one, so I started making my own with the help of my father."

"My hobby is dancing, especially the *jauk* and *baris* dances. One time when I was about to perform I looked all over but could not find my dance crown. Finally, I remembered that my friend had borrowed it a long time before. It seems he had lost it. I went to buy a new crown but was shocked at the cost. Dance crowns had become so expensive that I couldn't afford to buy one, so I started making my own with the help of my father. Since then, my dance crowns have become very popular in Bali. Ten people now work with me at my shop.

"It takes one to four weeks to finish a dance crown, depending on the style and complexity. We use a mixture of materials that, when carefully put together, make the dance crown very beautiful. Our materials include cowhide, rattan, wood, mirrors, velvet, gold paint, hair, cotton, wool threads, beads and colorful stones.

"In addition to making crowns for dance performances, we also create important crowns for sacred Balinese ceremonies. For example, we craft the intricate *paya agung* that is traditionally worn by men at weddings in Bali."

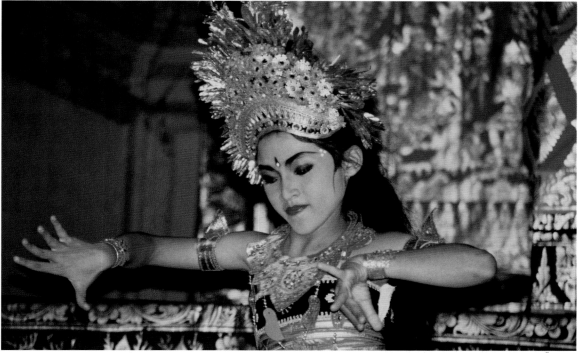

www.novica.com/keepers

29

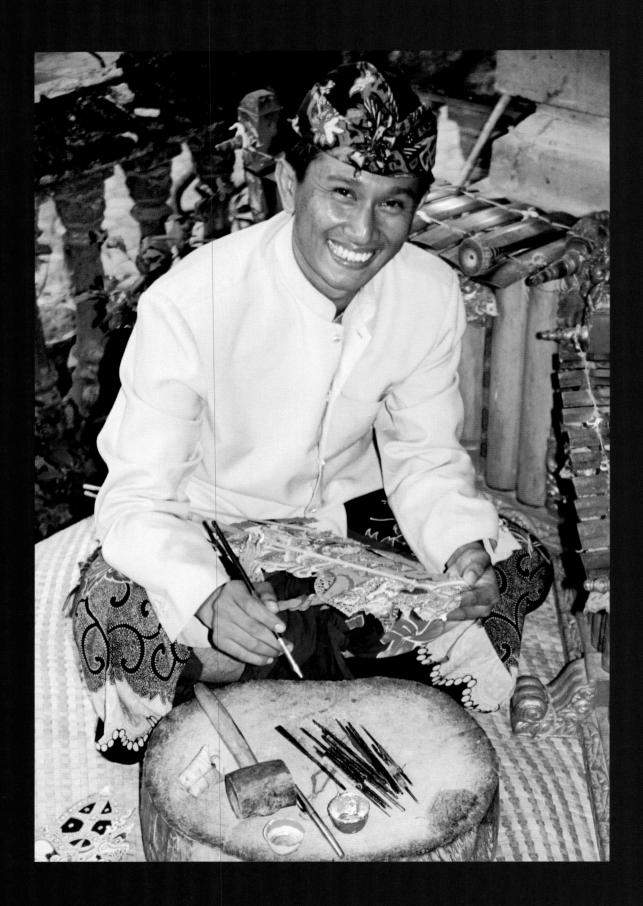

I Wayan Mardika Bhuwana

"I enjoy giving classes to children from my village, talking to them about our culture, and showing them how to make traditional puppets."

"For generations my family has been known for creating traditional shadow puppets. I started to learn how to make these puppets from my uncle I Wayan Wija, in 1984, and from I Ketut Agus Patha, a popular puppet-maker and performer.

"I make the puppets not only to sell but also to use myself, for in 1992 I began to learn the art of being a *dalang,* or puppeteer. That was when I began performing in Bali. In 1999 I was chosen as the best *dalang* in Bali, representing my region, Gianyar.

"I live, work and teach from the same home where my father once did. I enjoy giving classes to children from my village, talking to them about our culture, and showing them how to make traditional puppets. I have also taught visitors from the United States and other countries.

"I have a funny story that you might enjoy hearing, although it was embarrassing for me at the time: I was scheduled to perform in a village called Kramas, in Sukawati. My hosts offered some of my favorite Balinese food, *lawar,* which is very spicy. It was so delicious that I ate too much, and in the middle of the performance my stomach began to hurt terribly. I had to excuse myself to the audience, through the puppets, and take a short break. At least everybody enjoyed a good laugh!"

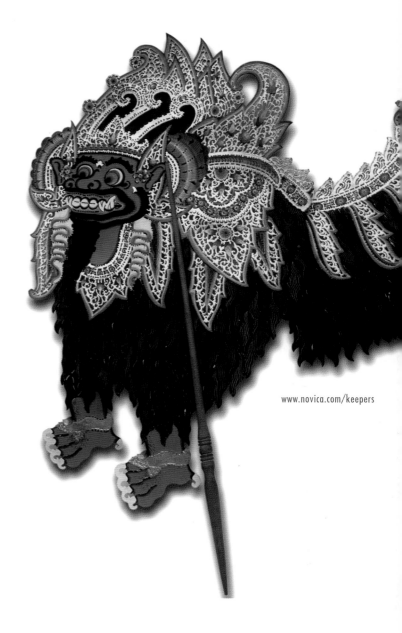

www.novica.com/keepers

31

I love my painting from I Wayan Rana. The tight draftsmanship and subtle colors just draw me into the picture, and his Balinese-style frames set it off wonderfully.

— Elaine Sweeney,
Cupertino, California

I Wayan Rana

> *"I enjoy themes such as workers in the rice fields, Balinese dancers and landscapes — what I like the most is to discover beautiful scenery."*

"I come from a poor family compared to the rest of my village, most of whom have farms and livestock to support them. But I am very grateful to God to have been born into a family of artists. My grandfather was a dancer and woodcarver, my father is a stonecutter, and I am a traditional painter. We are happy to have been able to live from our talents.

"I started to paint at age 10, and two years later was concentrating seriously on my technique, hoping to be able to earn a living from my paintings. I won an award while in school, and have since presented a number of exhibitions in Bali, including one at the prestigious Art Center in Denpasar in 1992.

"I enjoy themes such as workers in the rice fields, Balinese dancers and landscapes — what I like the most is to discover beautiful scenery. I use quills and very small brushes. Painters from Japan, Holland and France have come to learn the art of traditional Balinese painting from me.

"My career started with a memorable — if difficult — event, however. I was taking a painting to a gallery in Ubud. The painting had taken two months to complete. It was two-meters tall by one-meter wide, and I was carrying it on the back of a bike. Halfway there I fell off the bike because the roads were wet and very slippery, and crashed into a farmer cutting the grass by the side of the road. Luckily, no one was hurt. After cleaning and drying the painting by the side of the road, I continued into town and delivered the painting to the owner of the gallery. But then I noticed a small rip in the middle of the painting. I was shocked, but realized that when I fell off the bike, the farmer's scythe must have cut the painting! I was so embarrassed. I gave the money back to the gallery owner and sadly went back home with the beautiful but damaged painting."

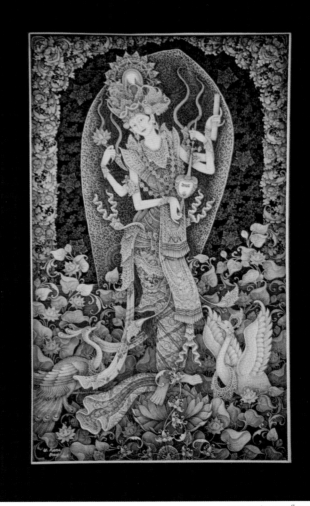

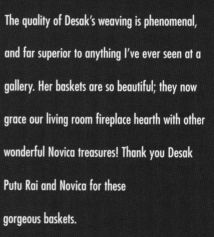

The quality of Desak's weaving is phenomenal, and far superior to anything I've ever seen at a gallery. Her baskets are so beautiful; they now grace our living room fireplace hearth with other wonderful Novica treasures! Thank you Desak Putu Rai and Novica for these gorgeous baskets.

— Dolores Rovnack,
Providence, Rhode Island

Desak Putu Rai

"We find great pleasure in this profession, sitting here every day, talking and weaving…"

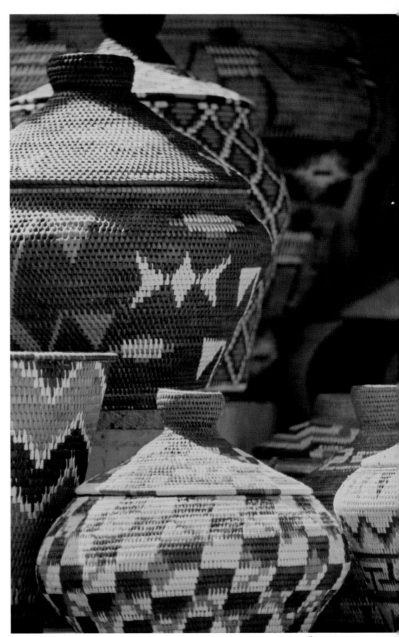

"My mother gave me the name 'Desak Putu Rai' during the traditional Balinese *telubulanan,* or baby-naming ceremony. My name means 'the younger Putu from the Knight Caste.' I began learning palm basketry from the neighboring craftsmen in 1990, and opened my own roadside shop in 1995. This is now our family business, and we enjoy it very much.

"My motifs and designs are inspired by the natural forms of leaves and flowers, as well as the ancient, primitive designs of our ancestors. The materials we use in my shop are the palm leaf and bamboo. We dye this material with teak leaves and brown clay. All of these materials grow naturally in our village.

"To complete one small basket we need five to seven days. Some of the baskets are small and simple; others are large with many decorative patterns woven into the design.

"We find great pleasure in this profession, sitting here every day, talking and weaving, sharing our conversation and our lives. We have been exhibiting our baskets with great success, and are highly regarded in Bali for the quality of our work."

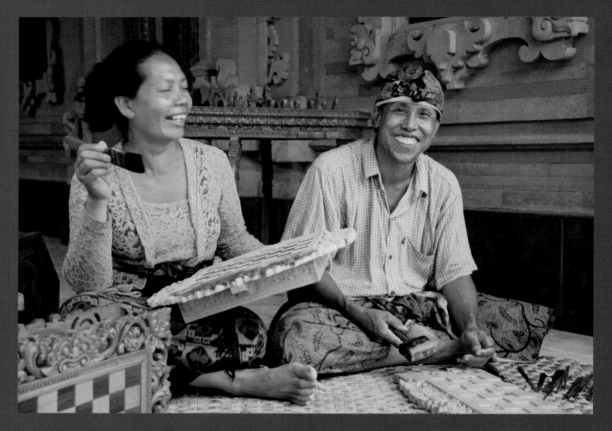

We just purchased I Ketut Sandi's "The Sea" chess set — it was the best Father's Day gift ever. It came very securely packaged and beautifully crafted, and is sure to become a family heirloom. Thanks Mr. Sandi, and thanks Novica.

— Tracy Esterly-Emerson,
Toledo, Ohio

I Ketut Sandi

"It is always our dreams and our belief in life that give us the best results, no matter how difficult the dream or how sore our feet get during the journey."

"Every time I think about my childhood, I remember that what I really wanted to do was what I am doing now. But because times were hard, I tried to learn how to do other things, like painting and statue carving — all to be able to make ends meet. In the end, however, what finally worked for me was to make my chess tables. It is always our dreams and our belief in life that give us the best results, no matter how difficult the dream or how sore our feet get during the journey.

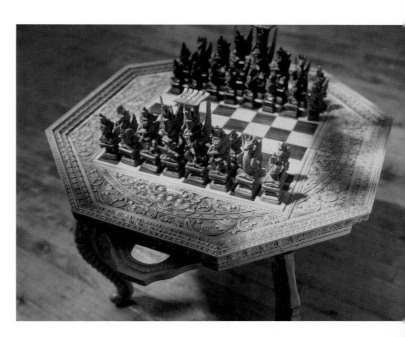

"I began my full-time apprenticeship in 1981. I studied under a master carver who taught me how to be more creative, even with ordinary figures. His creativity sparked my own; it was then that I had the idea to create chess sets, not only in the Western style, but also in a style that reflected Balinese culture.

"I tried to sell my chess tables at art fairs, but couldn't make enough money to support my family. So I tried to sell them on my own, walking up and down the streets of nearby villages. After a while of hard times and sore feet, I was introduced to Novica. I was very happy because the people at Novica were appreciative of my ideas. Soon, I was able to take care of my family, send my children to school, and focus on making even better quality carvings.

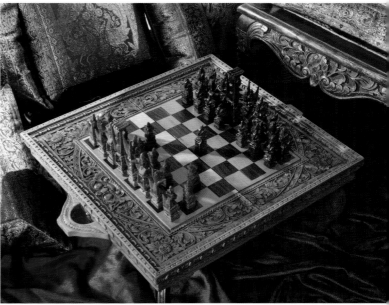

"I have now spent 17 years of my life crafting chess sets, and finally consider my efforts a success. My wife, Ni Wayan Putri, and 15 helpers now work with me to create these sets. We all learn together and work together happily, and continue to invent new designs."

I Nyoman Subrata

"What I wish now is to continue upholding the values of those who taught and inspired me, while being able to continue taking very good care of my family and my woodcarving group."

"My brother belonged to a group of master carvers in Bali who worked side-by-side for decades. Now, 28 years later, this woodcarving group still exists and I am its elected leader.

"In the beginning, my older brother, Wayan Sukamara, taught me the various techniques of sanding and finishing. In 1974 I began to sculpt, taking inspiration from some of the finest statues and carvings of our region. The traditional forms and poses were of strong beauty and fine workmanship, which inspired me to learn this style.

"My favorite statue themes are Cili, Garuda, Sri Pudhak, Barong, and the *singa* and *legong*. Rama and Sita are my favorite subjects for masks; these are traditional characters in religious mythology and offer a variety of ways for an artist to express creativity and style. For the past four or five years my work has been featured in exhibits in Bali.

"The influence of my younger years has continued to guide my work. What I wish now is to continue upholding the values of those who taught and inspired me, while being able to continue taking very good care of my family and my woodcarving group.

"In 1977 I married Ni Nyoman Jati. We now have four girls and one boy; three of them have finished school. We live in the same village where I was born.

"I have a funny story, one you might not understand if you did not grow up in Bali: It happened once when I brought some of my carvings to Denpasar, our biggest town. I visited the shopping center there, and saw an escalator for the very first time. I really wanted to try it, but not understanding how it worked, I tripped and fell. Everybody laughed at me. They thought it was very funny, but I was terribly embarrassed!"

39

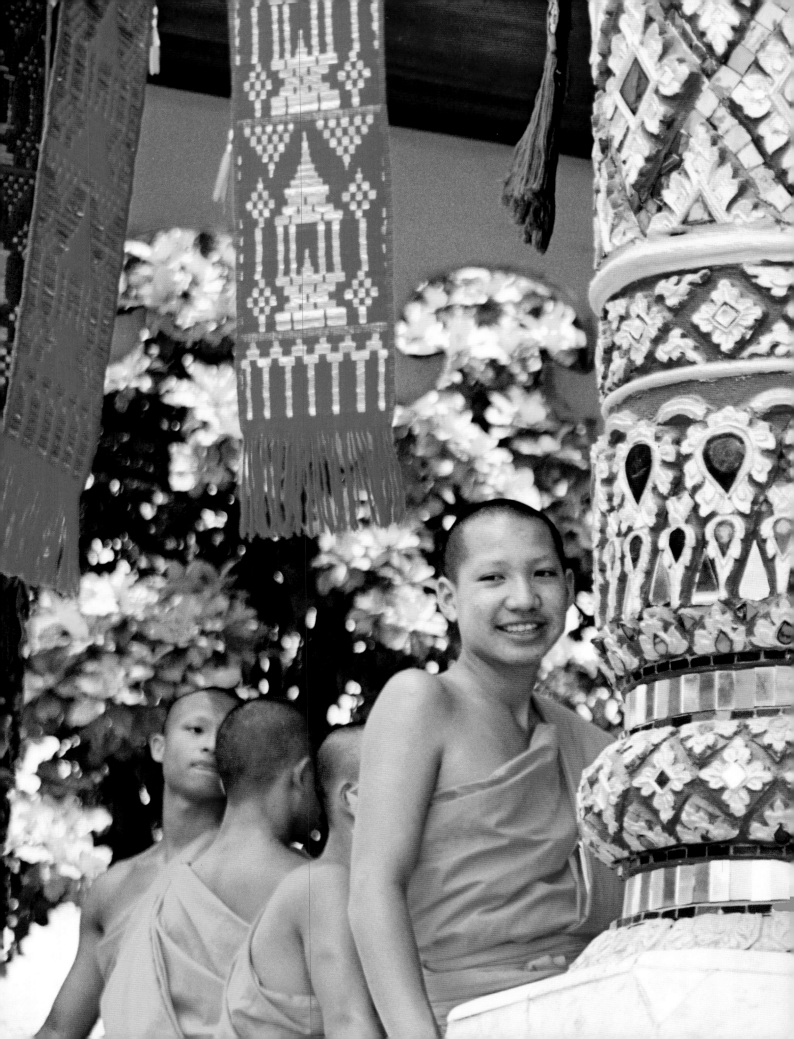

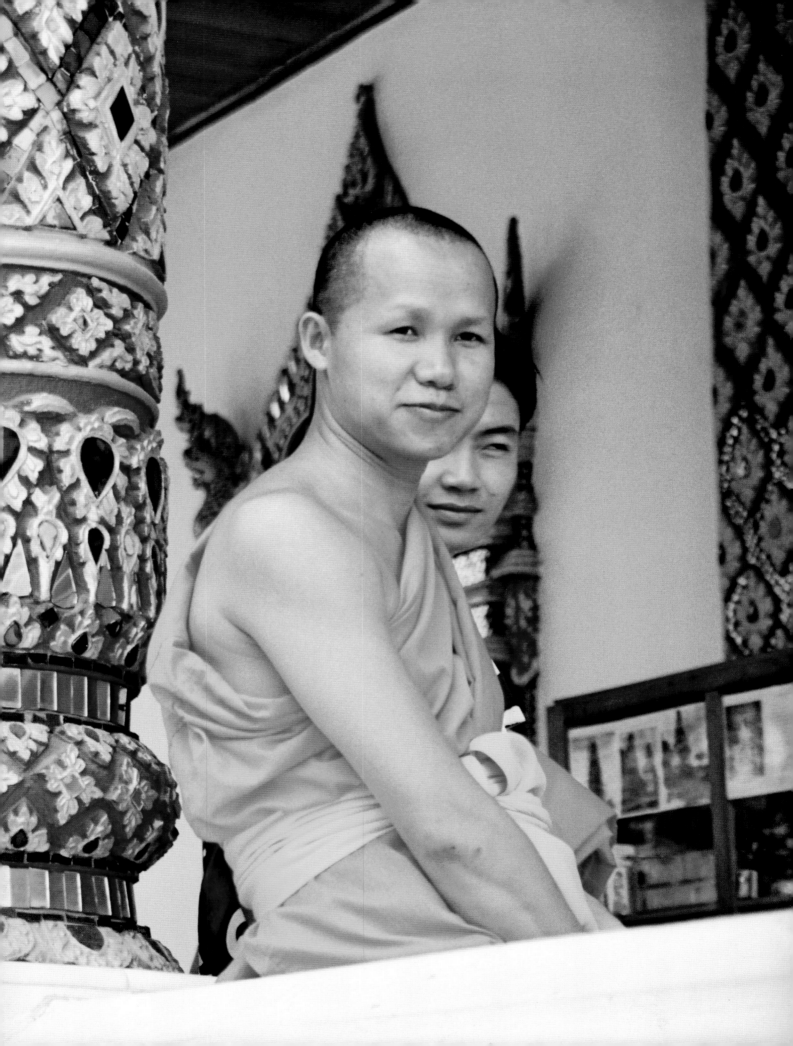

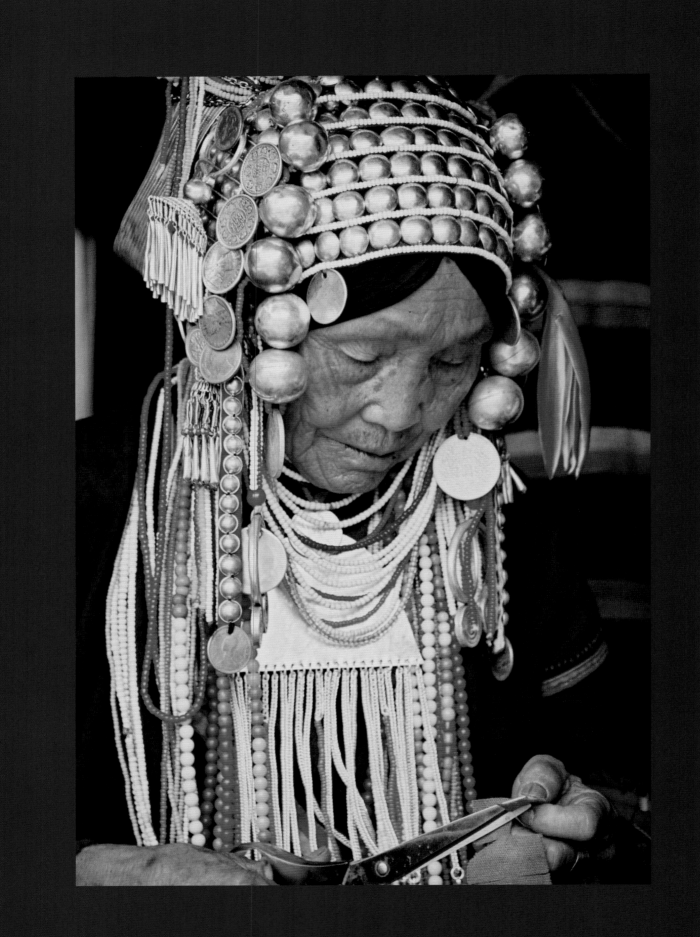

Aphi Mina

"Sometimes I get ideas from my dreams. Sometimes I look at the trees and a pattern comes into my mind."

"I am an Akha woman, from a hill tribe that originally lived in the mountains of China, Laos, Myanmar and northern Thailand. I was born in Myanmar in the 1920s. When war broke out there in the 1960s, my husband was killed. With my son's family and some relatives, we came to Thailand. For a long time we lived near the border, but it got very crowded with refugees there, so eventually we moved further south. We have been living here for almost 20 years now.

"Now I am too old to go to the fields, although I worked most of my life as a farmer. My son and grandson died young, so there are no grownup men left in our family. Fortunately, I can now support myself through my sewing, and have other responsibilities that keep me busy in our village, including important roles to perform during the rice-growing ceremonies each year. Also, many people in the village come to me for medicinal plants when they are ill or injured.

"It has only been for the past several years that I have been making Akha-style banners and handbags. My daughter-in-law and granddaughters sometimes help me with this work. We weave traditional, handmade Akha cotton cloth, and then use small scissors to cut patterns in other patches of cloth. With needles and thread, we sew these fabrics together to create beautiful things. We Akha have many patterns of our own, but for many years we almost stopped making our own clothes. Now we do this again, much more often, using our beautiful traditional designs and new ideas.

"I watch the movements of insects and animals, the colors of flowers and birds. Sometimes I get ideas from my dreams. Sometimes I look at the trees and a pattern comes into my mind.

"I like this work because this has always been an important part of our Akha way of life. I learned it from my mother and grandmother, and now I teach it to my daughters and granddaughters."

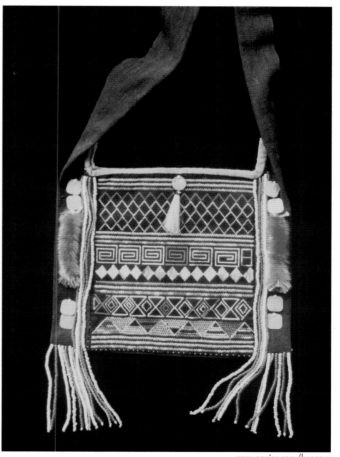

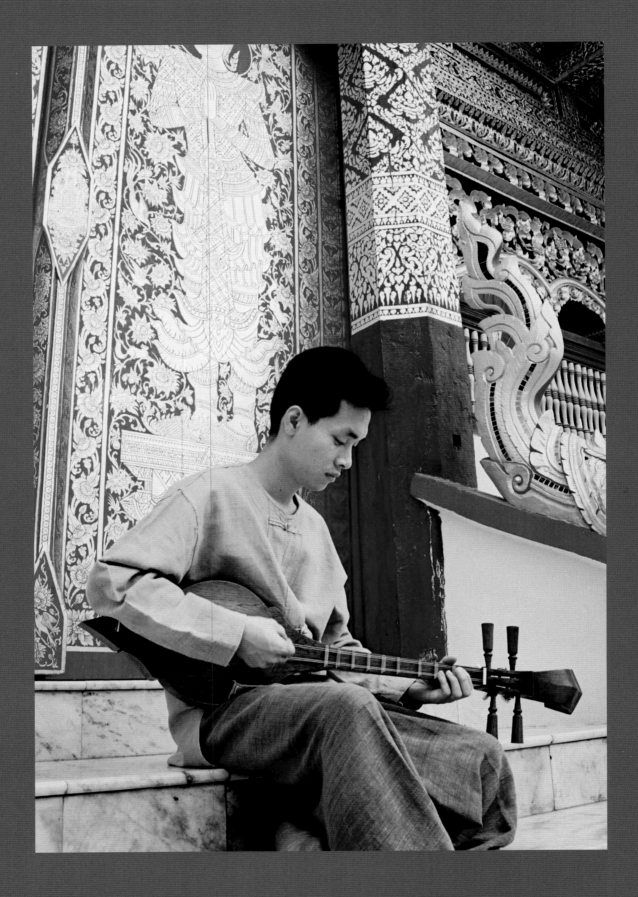

Somboon Gavichai

"In the Lanna cultural tradition, musicians didn't teach each other to play.... A musician proved his dedication to the art form by figuring everything out on his own."

"I became interested in northern Thai musical instruments when I was very young. One day on the radio I heard a very old, unusual song. I thought, 'what a strange style!' But it was beautiful. I asked my grandfather about it, and he explained that it was a local band playing traditional music, using a variety of ancient string instruments, including a *sueng* and *sa-lor*. I wanted to learn, so I began listening to old tapes that I purchased from market vendors. I also learned that the older musicians wouldn't teach me to play traditional instruments. In the Lanna (northern Thailand) cultural tradition, musicians didn't teach each other to play. Musicianship was considered a test. A musician proved his dedication to the art form by figuring everything out on his own. Also, music was traditionally used to win the heart of the woman you loved. Since it was so hard to learn how to play, a good musician was considered to be a patient person — an important quality in the eyes of potential in-laws.

"But with some help from my uncle Khum, who is a local master musician, and with a lot of experimentation on my own, I began to play the *sueng*. I practiced every day, following my uncle's strict advice. I played the *sueng* so often that I eventually damaged it and I had to learn to fix it myself. One day, after having repaired my *sueng* over and over, I decided to try and make a new one. I was 15 years old then, and that was when I started to make musical instruments. I made about 30 before reaching the sound, tonality and weight that I sought. At that point, I began to sell my instruments to other musicians, and now many young people have become interested in reviving our ancient music. I also helped found a traditional-style performance group, Lai Muang, which is now becoming quite popular in Thailand."

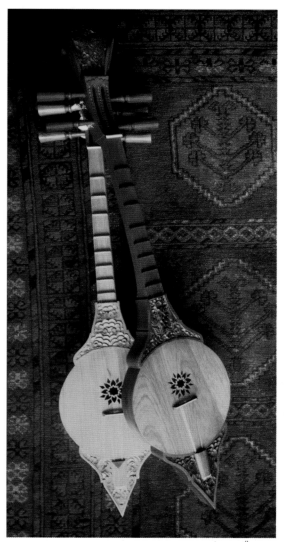

Ramphan Khumsingkaew

"My inspiration comes from Thai culture and traditions, and my personal experiences in day-to-day life."

"I am an artist in the celadon ceramic tradition, one of the three main ceramic styles in Thailand, dating back many hundreds of years. The traditional green tones of the glaze are intended to bring to mind the tonal qualities of jade. The celadon glaze is thick and strong, yet has many intricate weblike cracks in its surface for an antique feel.

"I initially learned how to paint basic patterns such as bamboo and lotus, focusing on that for three years. Then I learned more intricate and artistic Thai patterns that I have been painting until now. My inspiration comes from Thai culture and traditions, and my personal experiences in day-to-day life.

"Painting on celadon can be quite difficult, for this kind of ceramic has a rough surface; it requires much skill and patience, and it sometimes takes me a month to complete a single piece. I am very proud of my work.

"At present, I lead a happy and peaceful life. I have a loving family with two children. I intend to continue my painting career. I hope that my work will never be forgotten."

47

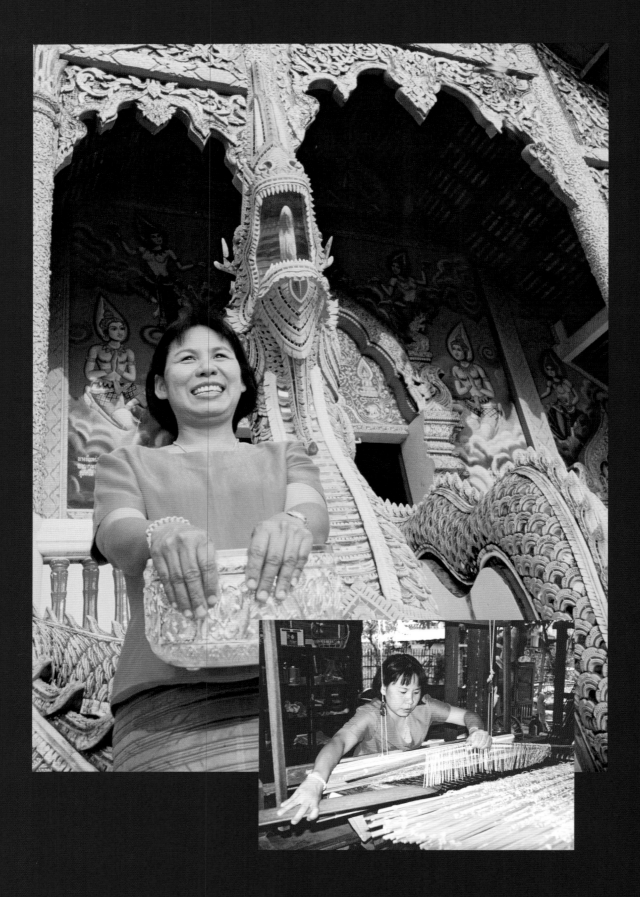

Orasa Khunsangkham

"If you want to weave silk you must truly love the fabric and be patient — only then will you succeed."

"I began my apprenticeship at 13 years old, and learned all the silk-making stages — and I really mean all of them: growing the worms, reeling the silk from the cocoons, dyeing the threads and, finally, weaving complex patterns on a loom.

"I learned everything from my grandmother, who was renowned for her expertise in silk. For many years I watched her weave various patterns such as *pha mai yok dok* (brocaded silk), or *chock sam thang* (a three-pattern design). One day, when she went away for a few days, she asked me to finish a skirt she was weaving. That was the first item I ever wove. It took me two years to master that particular pattern.

"When I was 29 years old I started to weave professionally. I no longer raise silkworms myself, but I continue to enjoy the complicated process of weaving silk on a traditional loom. I am now an expert at brocading silk with metallic threads, and my work has received considerable attention, which always delights me. I also enjoy teaching people who are interested in learning this ancient style, but few people really have the patience to master these techniques. If you want to weave silk you must truly love the fabric and be patient — only then will you succeed.

"Each time I weave a silk item, a fabric is created that cannot be duplicated — because it is hand-woven with different patterns, different colors and at different times. Still, even though I cannot weave the same item twice, I can proudly remember every piece of silk I ever wove. I look forward to continuing to weave silk every day."

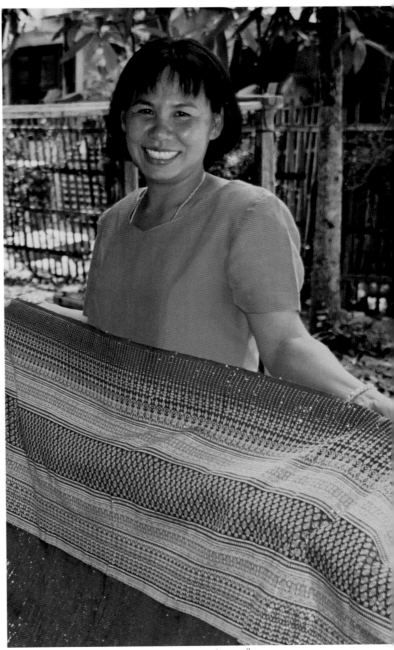

Lipikorn Makaew combines traditional

Buddhist mythology, ancient Thai painting

styles and intricate techniques with

tremendous flair and grace. His work is truly

unique. I'm now the proud owner of two of

these wonderful works of art.

— Frances Hoffman,
West Hollywood, California

Lipikorn Makaew

"I wanted to show how faith, wisdom, peace and Thai Buddhism were passed down to us..."

"I grew up in the rural village of Baan Buakkhang outside of Chiang Mai. It is a peaceful village — its heart beating with the slow pace of Lanna, of northern Thai tradition. I have always loved the arts and the religious ceremonies and festivals that we inherited from our rich cultural past. Even as a child I loved participating in temple ceremonies and festivals. At 12 years old I decided to become a monk, and I lived a monk's life for four years. Those four years left me with strong feelings and impressions about everything that involves religion, culture, ceremonies, festivals, arts and crafts — particularly from my native Lanna culture.

"I wanted to convey to others the easy and peaceful way Lanna people live their lives. I wanted to show how faith, wisdom, peace and Thai Buddhism were passed down to us through our important ceremonies. Deciding to express these deep feelings through the arts, I learned the exceptional Lanna artistic style, which is a very different style than elsewhere in Thailand.

"I have received prizes of various kinds, including an award bestowed by a member of Thailand's Royal Family, which left me deeply honored. I was also awarded a medal by our Prime Minister, which filled me with untold joy and pride. My personal success made me realize that the ancient Lanna style is still of great interest to the Thai people, and to many others outside Thailand as well. In 1985, with Somboon Gavichai, I helped establish the Lai Muang performing arts group, teaching Lanna culture, arts, music, dance and traditional rural ways of life."

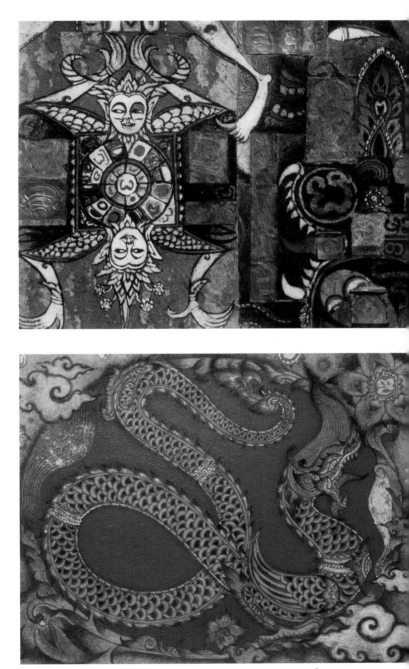

Africa

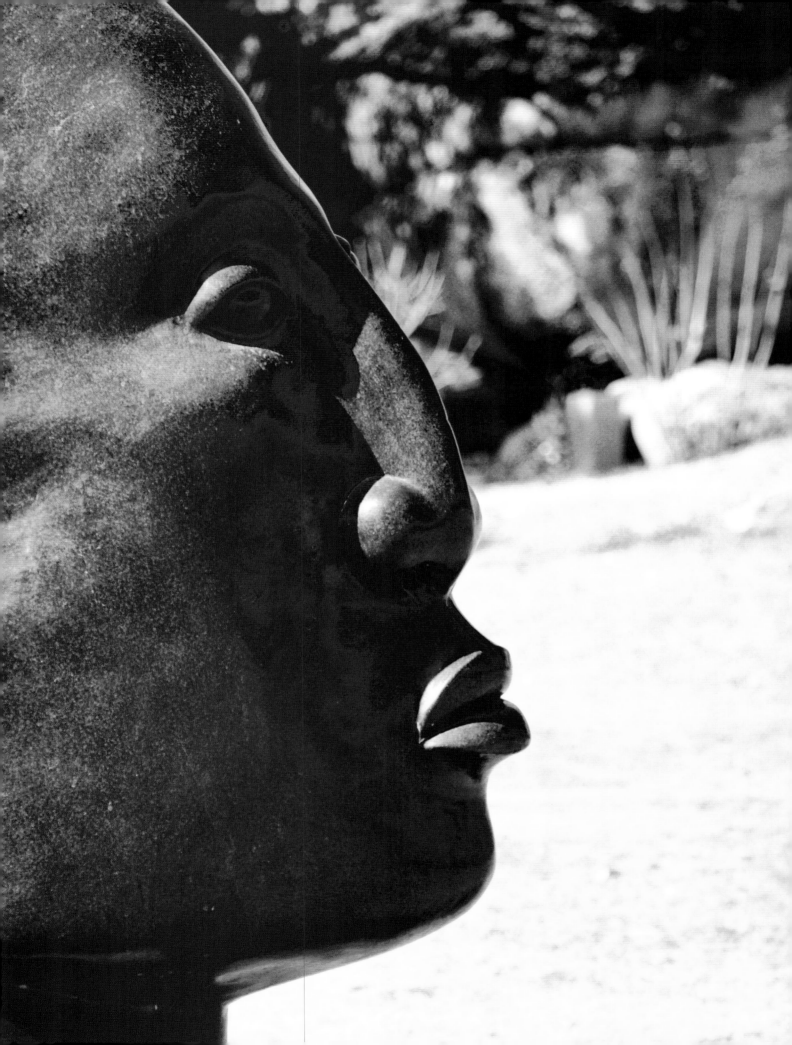

Of Carvers and Kings

An invitation arrives from West Africa...

he morning sun rose over Africa like wildfire, setting the edge of the world ablaze. Soaring along in our window seats, 20,000 feet above ground, mile after mile of golden dry savanna and a few scattered villages were the only sights for hours.

We were on our way to Novica's West Africa office to interview artists and join them on a journey to visit King Otumfou Osei Tutu II, the most influential tribal chief in the region. The exciting invitation from the Ashanti leader arrived at Novica headquarters several months earlier; Nana Frimpong, the king's chief carver, had delivered the message. Nana had joined Novica two years prior to supplement the "honor salary" he receives from the palace, and has impressed the king with his success on the Internet. The king had requested our presence at the annual *Akwasidae* ceremony, a celebration giving thanks for the year's blessings. We were invited as guests of honor, a gesture of thanks for Novica's work in the region.

Deplaning at the small airport in Ghana, we cleared customs and headed toward a sea of unknown faces, hoping to spot someone from Novica's local team. José Antonio Echeverria, Novica's world-wandering vice president of international operations, was first to greet us. Except for frequent communiqués through cyberspace, our paths crossed infrequently — always in remote corners of the globe. With José Antonio were Edward Humado and Isaac "Kofi" Kyeremeh, directors of Novica's Ghana office. After bear hugs all around, the trio ushered us through the crowd and into a waiting car.

En route to the hotel, we brought each other up to date on the latest developments in our various missions and discussed the week to come. The Novica team had just moved into a new office. Tomorrow would be a big day; many artists were coming to see the new facilities and help decorate. The day after, we would drive to Kumasi, in northern Ghana, to the palace of the king.

In the morning, we arrived to a festive atmosphere in the office. Staff members were coming and going, furniture was arriving, and technicians were busy at work installing Internet lines. Several artists were decorating the walls with their prized works. Dramatic metal sculptures by Kola Ogunsunlade graced the second-story artists' lounge, where many visitors were already milling about.

Painter Emmanuel Mawuko Arkutu showed me his business card, complete with Novica's logo: "Visitors see my business card," he explained, "and ask, 'Your paintings are on the Internet?' 'Yes,' I say, and then they see my paintings in an important, international context."

I asked him about his strikingly diverse styles and subject matter. "I talk about African culture and history through my paintings," he said. "War scenes of the Zulus in South Africa, musical scenes, changing fashions, landscapes, and slavery — my paintings are metaphors calling for the African to break free from all forms of mental slavery. No one is in chains now, but why do we remain in mental chains?" He shook his head. "The title of one of my latest paintings is 'Day Break Africa.' This painting says, 'Hey! Hey! You've got to wake up. We're free: Be free of your mental slavery.'"

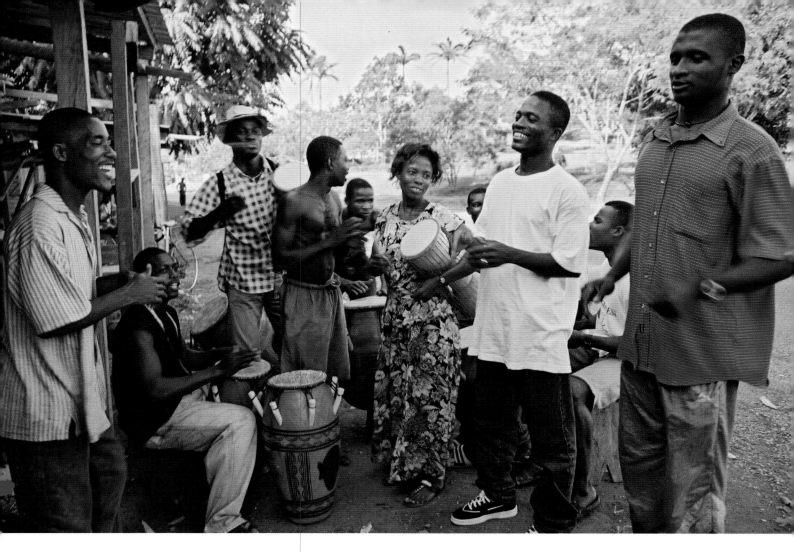

Just then, Ernestina Oppong Asante and her husband, Daniel, arrived from the village of Aburi, an hour-and-a-half distant. Ernestina's *djembe* drums are popular on the Internet.

"As a young lady, I decided to make my own way," Ernestina said. "First I became a dressmaker. To learn any skilled trade in Ghana, you must first apprentice for several years, earning no money and typically paying the master teacher. So I began waking up in the wee hours to bake bread, selling it early in the morning to earn enough money to pay my dressmaking master at my full-time dressmaking job."

Two and a half years later, Ernestina earned her dressmaking certificate. As there were many dressmakers in Ghana, she explained, orders were few and far between. Meanwhile, she had fallen in love with drum-making —

her first husband's craft.

"He wasn't terribly faithful, but improving my career was more important than seeking revenge," she chuckled, "so I told my husband I wanted to learn how to make drums because I wanted our marriage to be even better. It was calculating, I know, but I was determined to have a better life."

Ernestina's husband didn't like the idea. "He said carving drained women of their wifely energies," Ernestina recalled. So she arranged clandestine woodworking lessons. "My husband's apprentice served as my master teacher!" she laughed. "It was terribly ironic. But, by the grace of Jehovah and my new husband — also a carver — I've now succeeded," she concluded. "Our life is wonderful now. We make drums together all day, and now have several people working with us."

We also spoke with Amuda Sulley, a fantastic young mask-carver. After asking about our travels, he explained that his greatest dream was to journey beyond Ghana's borders. "I am saving money and carving more than ever, with the goal of traveling to many lands," Amuda said, adding that he planned to start his travels in Italy.

Amuda shared how, while his father had wanted him to attend high school, "I chose to carve instead. Now, when I see my classmates, I say to myself 'Ohhhhh' — some of them are important, successful men now. But then, I love to carve, and I am also becoming successful. Perhaps one day I'll be as successful as they are — doing what I love to do."

The next day we drove several hours north to Kumasi, and the home of the king's chief carver. Over dinner, Nana Frimpong explained the story of his chief-carver status. "In the old days, there was a war between the Ashanti and the Denkyira," he explained. "Sixteen generations ago, when my Denkyira ancestors surrendered to the Ashanti, our leader collected plantain leaves to signify that he wanted to sit down at the table with the Ashanti king and make peace."

Peace was made; instead of killing them, the king gave the Denkyira tasks to perform. Known for their carving, "my family was ordered to carve for the king. This was their punishment, instead of being hanged. We gladly accepted our task," Nana said. Over time, he explained, what had been punishment grew into an honor. "Now we are actually sub-chiefs and decision-makers in our kingdom."

Nana carves the king's thrones (referred to as "stools" in Ghana) along with other palace artifacts. The king has presented Nana's stools as gifts to the President of Nigeria and to Pope John Paul II. I commented on Nana's popularity through the Novica Web site. "I am proud to represent my culture to the world," he replied,

"and I carve with great care, for my king is not a small king." Nana told us his income had tripled since he joined Novica, and that two of his sons now attend university — the first members of his family ever to receive a higher education.

Nana said that fellow villagers now regularly seek his counsel on all manner of important affairs and business concerns. He spoke of how the Internet made a tremen-

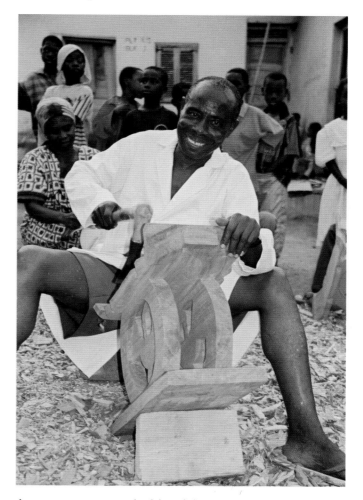

dous, positive impact on his life and those around him. "I used to have a much smaller knowledge about the world outside Ghana," he explained. "I looked at the outside world with malice because I did not understand their way of behavior. However, this has totally changed, because the outside world has a lot to offer us in terms of technology, investment and knowledge about other cultures."

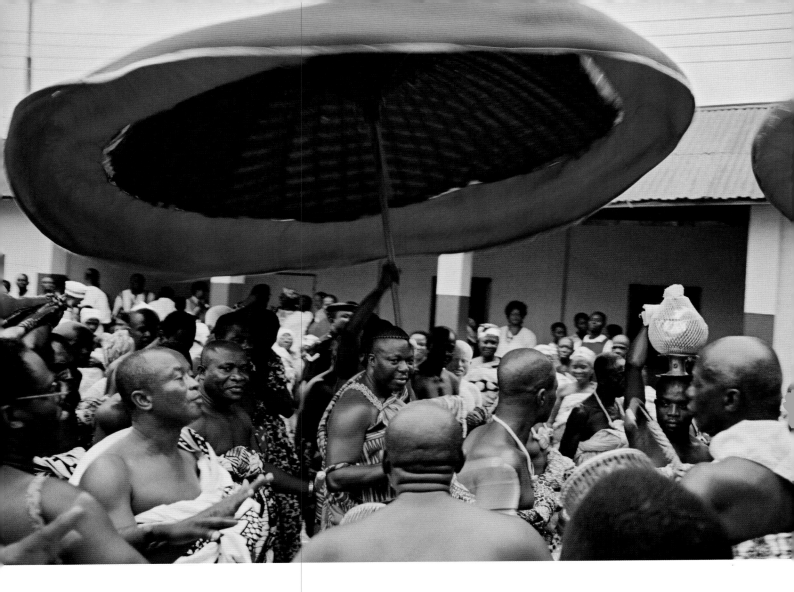

The next morning we met Nana and another great
Novica artist, Yaw Baafi, outside the Ashanti palace.
Numerous dignitaries and two kings of nearby regions
milled about in front, enjoying the breeze. Nana intro-
duced us to all, including the Ashanti king's chief cloth-
ier, barber, and shoemaker. The three regal-looking ser-
vants were taking a break from their work, sitting side-
by-side and people-watching from a low stone wall.

Ushered into the palace courtyard, we were told it was
time to take our seats; the ceremonies were about to
begin. We sat beside the king's secretary, several assis-
tants, and one of his security chiefs.

The sounds of talking drums soon filled the old, out-
door pavilion. A young male dancer began performing,
spinning and moving his body to mimic the drumbeats
with the power and grace of a martial artist. Other
dancers took over, and the entertainment continued for
some time before a hush descended. Then the Ashanti
king and his 350 attendants began filing in. One of the
king's assistants beside us pointed out the Keeper of the
King's Gold, who balanced a gilded vase full of gold
upon his head. Next came the royal umbrella bearers,
and the king dressed in regal robes of golden *kente*
cloth. Behind him walked his fanner, food-taster, sever-
al eunuchs, and hundreds of other attendants. We spot-
ted Nana Frimpong among the ranks.

The procession neared, then turned and headed in our
general direction. Soon the king was seated nearby —
on a beautiful throne made by Nana.

The ceremonies lasted for several hours. Representatives from various regions of the Ashanti nation came forth, bowed to the king, and presented reports. Each spoke not to the king directly but to his "voice," a man standing beside him. The voice then repeated the information to the king before relaying the king's replies. Kofi reminded us that we, too, must speak to the king's voice, not to the king directly.

Soon the king's chief secretary called our names. We followed Kofi in close step, stopping at a distance before the patriarch to bow, each in our turn, as we had practiced the day before. After a brief interchange, we returned to our seats to enjoy the festivities to follow; our private meeting was scheduled for later in the afternoon.

Later, in the king's private chambers, we bowed low again before taking our seats in a semicircle. Nana spoke first, through the king's voice. Next Kofi spoke, before turning and asking me to approach. I stood and bowed again before — through the king's voice, of course — answering his questions about Novica.

The king spoke at length about his primary passion — strengthening the educational system in Ghana. Education has been his rallying cry since assuming the throne in 1999. Before that, he worked for many years as a businessman in Ghana and Great Britain. Though the king wields no legal authority in Ghana, he holds considerable influence over his people. Ghanaians have great respect for the current king, Kofi explained, and believe him to possess great vision and a much deeper understanding of the outside world than have his predecessors.

"I'm very concerned about creating work for our people," the king explained. "If Ghanaians have work, they can better contribute to their children's welfare and education. Education is everything — the key to progress." He thanked Novica for contributing to his country by connecting artists with greater possibilities for commerce worldwide.

The king praised Nana, explaining that Nana's success had brought hope to the palace and to the Ashanti people. He extolled Nana for setting an example to his entire community, proving that average citizens can indeed bypass the limits of their economic environment.

"Ghana is home to many extraordinary artists and other skilled workers," the king said, "many of whom can be helped through the Internet and through private enterprise as Nana has been helped by you." He concluded "the government cannot provide jobs for everyone, yet there are many Nana Frimpongs in the Ashanti nation. It is through a unified effort with private enterprise that we will be able to bring about change."

We spent several days at the palace, leaving with barely enough time for the long drive back for our flight from Accra. Once there, we unloaded our luggage and made our way through the crowded airport; it was time to run — fast — to catch the plane.

Jogging up the airport stairs and through customs, my heart pounded as we hurriedly made the final boarding call. Suddenly disoriented, a stranger grabbed my arm, spinning me around to face him.

"We've been here for three days," the man said, desperately motioning to a crowd of people congregating about and sleeping all over the floor. "We can't get to our country. What should we do?" He looked at me, shaking his head sadly. "The fighting there won't stop…. There's nothing that can be done."

Thus we were reminded that, despite the pleasures of our visit, all was not well in many parts of Africa. Climbing the stairs to our safe passage home, we contemplated what might be done, and sought yet again a deeper appreciation of all good things — including peace.

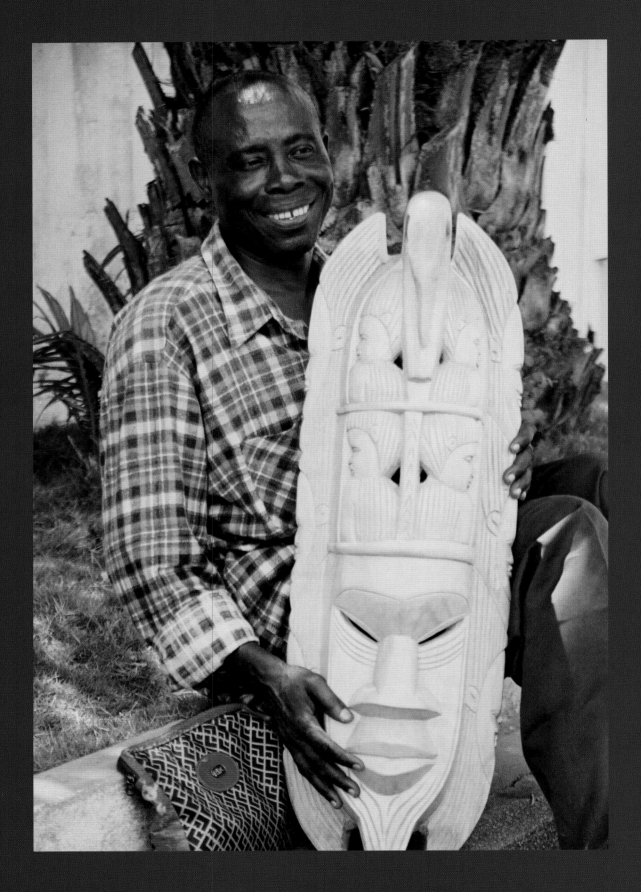

Nana Frimpong

"I am currently the chief carver for the King of the Ashanti, because of my great ability in carving."

"I am currently the chief carver for the King of the Ashanti, because of my great ability in carving. Some of my work for the king includes objects with the *gye nyame* (symbol for the supremacy of God), stools, staffs and other royal and ceremonial objects. I have trained and qualified some 10 men in the art of skilled carving. I draw inspiration from traditional *kente* cloth designs, from my family background, and from our rich Ashanti tradition."

"After leaving school I took up carving as a trainee under my father, Kojo Duah. Later, Professor Ablade Glover of the University of Science and Technology spotted my work. I ended up staying under this man's tutelage from 1970 to 1972, compiling additional skills and experience through his direction and guidance. This led me to decide to establish my own workshop.

"I would like the outside world, especially those who buy my works, to know that Ghana has a lot to offer — not only in terms of human resources, but also very good products and artworks like the ones that I create. Every carving that I make has a message; we hope that people will enjoy and appreciate the messages of our culture.

"My dream has always been to invest in my children's education. I am happy to say that this is now possible — two of my sons are in university, the first of our family to obtain a higher education. My other primary goal is to help my community, so that the poverty that plagues them will be eradicated completely. Above all, I wish to help make it possible for peace and tranquility to prevail in my community and the nation of Ghana as a whole.

"My advice to the world is that we should as a matter of urgency stop all wars so as to make the world a better place for everybody to live in. If we all cherished hard work and dedicated ourselves to our professions, the world would be a more peaceful place."

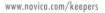

www.novica.com/keepers

61

Joseph Kwadjo Aboagye

"I especially enjoy working in front of the sea. It fills me with great inspiration to work there and to wonder who in the world will next touch the drum I am making."

"When I was in the fourth grade I went to live with an aunt who was and still is working at the Arts Center in Accra. So I virtually lived my life growing up at the Arts Center. I helped my aunt and meanwhile took great interest in the way various carvings were made.

"I understudied for almost all the craftsmen at the center, and as a result I am now able to carve fine drums. From the beginning, I loved the tasks involved in carving and concentrated on them exclusively in my spare time. I had a friend who was also interested in drummaking, so in 1999 we joined forces to open our own small business making drums and carvings. I have many customers now, including cultural troupes and people from all walks of life, from all over the world.

"I especially enjoy working in front of the sea. It fills me with great inspiration to work there and to wonder who in the world will next play the drum I am making.

"We test each drum for sound and tone quality — the part of the process we enjoy most, and the final touch that guarantees that every drum that departs my shop carries with it great sound and quality."

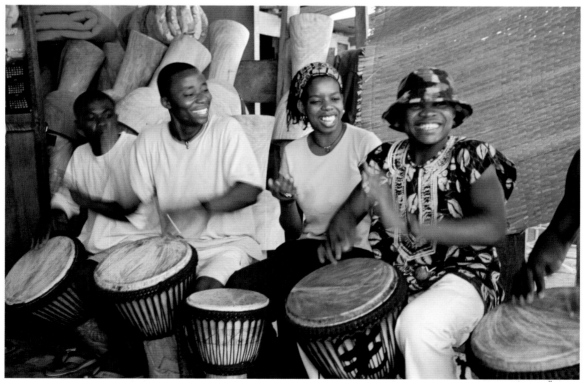

www.novica.com/keepers

Seth Korkordi Selom

"My childhood days were marked with art activities. Aided by the crayons and watercolors that my father often bought for me, I would draw all over the house."

"Art, I believe, is a gift that some members of my family — including yours truly — have been endowed with. I was born at Asylum Down, a suburb of Accra. My childhood days were marked with art activities. Aided by the crayons and watercolors that my father often bought for me, I would draw all over the house. My mother explained that my grandfather had been a very good carver. She showed me some of his work. I was fascinated, and my innate interest in art was given a boost by this family connection with the arts.

"I had a six-year primary education at Ann's Preparatory school in Accra, after which I had a seven-year education at the Presbyterian Boys' Secondary School, Legon — one of the top colleges in the country — to acquire both the ordinary and advanced level certificates. At all these various levels of education I was always judged the best student in art.

"Much of my success is owed to a friend called Mawoko, who in 1994 introduced me to serious painting and inspired me to acquire the skills involved. Until then I was familiar only with drawing. I used to visit this friend at his Abelenkpe residence where he did both abstract and portrait painting. Before long, I found myself painting!

"I paint mostly still life and nature scenes, and have been working full-time as a painter for about seven years now, suspending work only briefly to further my education. During this period I have participated in several group exhibitions. Significant among them have been a Pan-African exhibition and an exhibition held in Accra as part of a week-long cultural festival in 1995. My most recent exhibition, titled 'Eyes Through the Third Millennium 2000,' was featured in The Daily Graphic, a popular national newspaper."

Latin
America

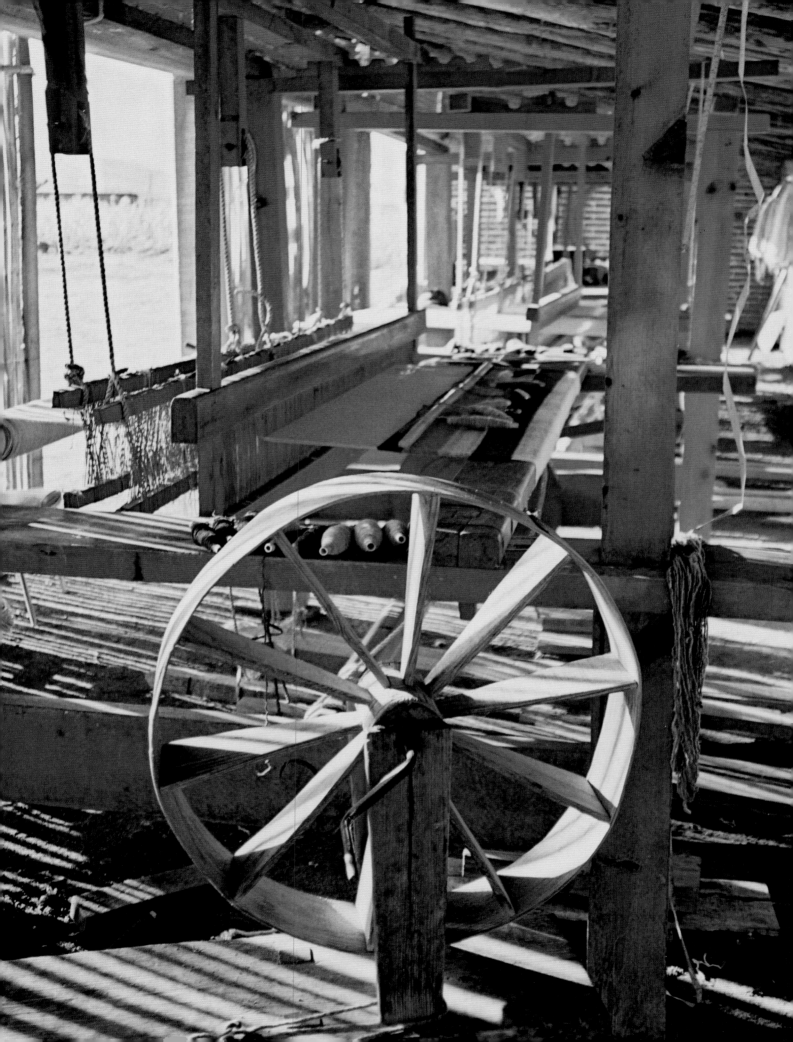

Wild Dragons and Golden Looms

Deep in the heart of Mexico

Spend just a few hours at the Ruiz Bazan family farm and you will understand why we didn't want to leave. No telephones, warm hospitality and everything made by hand — from the mouth-watering Oaxaca-style tortillas served at breakfast to the extravagant Zapotec rugs woven throughout the day. The clock seems to have been turned back centuries.

Israel Ruiz Bazan had invited us to spend the weekend here, making an irresistible offer of private weaving lessons, rooms with a view and delicious home-cooking. Israel helps his father Gregorio run the family farm in Teotitlan del Valle, near Oaxaca, Mexico — a small village where nearly the entire population dedicates itself to the elaboration of tremendous textiles.

The Ruiz Bazans work side-by-side; grandparents, aunts, uncles and cousins spinning wool together and then helping each other weave it into works of art. The ladies tell entertaining stories all day in indigenous Zapotec (few women in the family speak Spanish, so the men — who have traveled outside the village and have learned it — translated for us). The weather is temperate year-round, so everyone works outdoors under the shade of thatched roofs, enjoying the priceless view. The family's ancient looms face out on a magnificent vista of low-lying blue mountains and miles and miles of unspoiled countryside.

Rosa Bazan Mendoza, the beautiful 65-year-old matriarch of the Ruiz Bazan clan, taught us to card wool, the first step in the complex process of rug making. She kept careful watch while we spent our first day combing heap after heap of freshly shorn sheep's wool, gradually filling large baskets with our finished work. When all the wool was carded, we washed it in a large stone basin and then spread it out to dry.

Israel's cousin Domingo then showed us how to spin the raw wool into yarn. Cristina and Delfina worked nearby, grinding tiny dried *cochinilla* bugs into a brilliant red powder. Just a pinch of the powdered bugs would stain the wool a rich, ruby red.

By the time we'd spun all the wool, the yard was ablaze with numerous bonfires. Each supported a large, ceramic dye basin filled with spring water. Soon the water began to boil, and Cristina and Delfina began adding different dye materials into various basins. We followed, dropping heaps of spun wool into each cauldron. Two handfuls of eucalyptus bark turned one batch of wool a warm shade of tan; green leaves from a native shrub produced a dusty-gray result; fermenting pomegranates dyed yet another batch a sunny yellow. Miniature pansy-like flowers, growing wild in the yard, served as brilliant purple dye.

When the dyed wool came out of the cauldrons, we washed it thoroughly and then carefully draped it out to dry overnight. It hung like heavy laundry on ropes strung across the yard.

Each night, Rosa, Evelia and Cristina prepared a delicious dinner for the entire family — salads of fresh

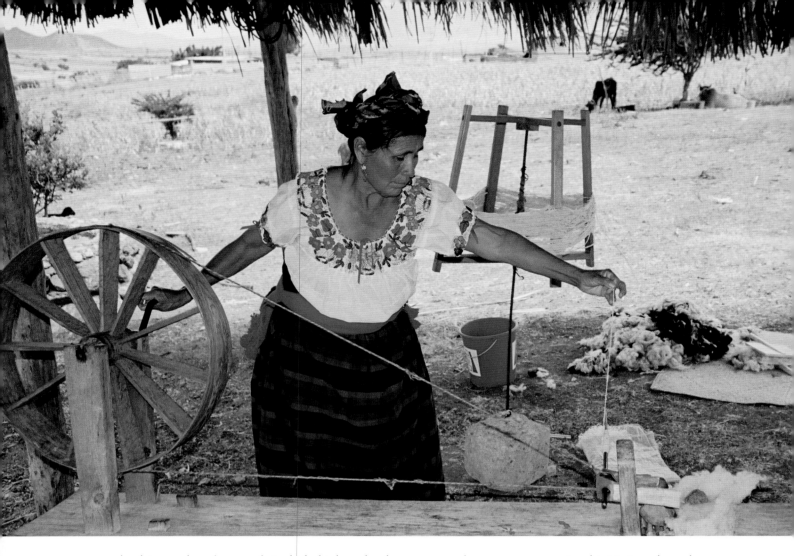

local greens, hot *champurrado* (a thick drink made of cornmeal, water and locally grown, bitter chocolate), *caldo de chapil* (a soup made of wild greens) and bowls of sliced squash and steaming corn.

We passed around plates of fresh, salty Oaxacan cheese and baskets of fresh tortillas, tearing the tortillas into pieces and using them to scoop up the delicious soup. Fresh red-chili paste, sea salt and heaps of juicy, sliced green limes flavored our feast.

The family asked us many questions about computers and the Internet. Israel has been taking a bus to another town once a week to attend computer school. Because the Ruiz Bazan farm is so far from Novica's Mexico office, José Cervantes, founder of Novica Mexico, had installed a computer for Israel to use in a home with a phone line nearer to the town center. Israel said he's enjoyed learning

to use the computer to monitor his Novica sales and communicate with us across the many miles.

"It helps a lot to have the computer," Israel told us. "It's so interesting because at any time, while we're here on the farm, a sale could suddenly happen anywhere in the world. We don't have to travel all the way to the city to try to sell our work. We are selling many more rugs without leaving home. This has made our lives much easier."

Before dawn the next morning, two of Israel's cousins lit the fire in the cookhouse and began kneading cornmeal into oversized, Oaxaca-style tortillas. I wandered outside to join them, and they quickly put me to work. They showed me how to form the fragile tortillas and then quickly toss them onto the hot *comal* to cook. It proved a tricky feat to throw the tortillas fast and sure enough so they didn't skid and wrinkle on the *comal*. We shared

a good laugh; theirs in disbelief that such a common task could prove so difficult for me. Meanwhile the older women were hard at work in the main kitchen, preparing big jugs of hot *champurrado* and laying out sugary breads, salty wet cheeses, more sliced limes and bowls of squash soup to feed our healthy, hard-working appetites.

After breakfast we spun the dyed wool into yet finer yarn and bundled it on small shuttles. Domingo then taught us how to weave it on the looms. He watched attentively while we tossed the shuttles of dyed yarn back and forth, back and forth between the two layers of base threads that stretched across the loom, simultaneously working its pedals with our feet.

"*Uno menos,*" or "one less," Domingo would remind us; "*uno menos*" again a few layers further along, making sure we didn't forget to gradually weave shorter and shorter lines to create a tapered, zigzag pattern in the emerging rug. To lose count would ruin the carpet, Domingo reminded us, leaving an irreparable blotch in the design.

Andrés completed a larger rug on a neighboring loom, one that had taken several weeks to weave. Juliana carefully examined the rug for stray bits of straw or other chaff that might have worked its way into the wool. Using tiny scissors and a fine-toothed comb, she meticulously tugged, snipped and cleaned every inch of the beautiful big rug.

We all gathered around to admire it. Israel's son Guillermo and three of the family's other young children joined us.

"Show us how well you can dance," Israel encouraged Guillermo. The little boy hid shyly behind Juliana's skirts. Israel explained that his son attends dance classes at school, training to perform the traditional *danzante* dance.

Oaxaca is world-renowned for its extravagant *Guelaguetza* folk-dance festival. Once a year, hundreds of top dancers from Oaxaca's seven regions descend from the mountains and emerge from the desert, converging on the capital to showcase their state's many regional dances for an audience of thousands. The pre-Columbian dances honor the gods of wind and corn. The Ruiz Bazan family hopes that when Guillermo grows up he will be chosen to perform the *danzante* at the *Guelaguetza,* representing Teotitlán del Valle.

Guillermo overcame his stage fright and leapt from behind Juliana, first hopping on one foot then gracefully bowing and spinning right and left, back and forth with intricately choreographed steps. I pictured him, years from now, taking the stage, regal in a bejeweled headdress and woven rainbow robe, dancing before the governor and thousands of cheering fans at Cerro del Fortín, the outdoor amphitheater in the mountains above the state capital.

Soon thereafter we packed our bags and sadly took our leave, wishing we could remain much longer in the welcoming company of the Ruiz Bazans, enjoying their tranquil farm.

From the Ruiz Bazan farm, it was an hour's drive to San Martin Tilcajete to visit Joaquin Hernández Vasquez, another artist who works with Novica. We found his front door a sharp contrast from the others that lined the dusty main street: Larger-than-life, fire-breathing lizards greeted all who dared approach. A modest "Wood Figurines" sign gave little hint of the treasures waiting within.

Once inside, wildly painted beasts, serpents and frightening insects lurked among the hundreds of wooden creatures ("*alebrijes*") facing the door. All appeared poised to attack, forked tongues flickering and devilish stares ablaze.

"You can see how we felt the day we made a particular piece by looking at the passion with which it was created," Hernández explained after welcoming us inside. He pointed to a sly, painted cat and a band of happy devils nearby. "You can tell if we were sad, happy or angry. You can easily read our desires, our thoughts and our emotions."

Though Joaquin was accustomed to his work being photographed for the Web site, we politely asked permission before taking new shots — most *alebrije* artists won't let their work be captured on film at all, believing that the photograph steals the soul of the *alebrije*.

"This town lives by many myths and traditions," Joaquin said. "They say the photograph takes the little animal's luck away — and a soulless *alebrije* won't sell. But I don't believe this.

"For me," he continued, "it's an honor to have my work photographed. Sometimes people have wandered into my shop and become so emotional over a piece that it's even brought tears to their eyes. It makes me proud that someone admires and appreciates my work.

"And," he added with a wink, "so far, the photographs

have brought me great luck!"

We couldn't stay long. José had scheduled early evening meetings with several artists in Mexico City, still a plane ride away. We drove back down into the Valley of Oaxaca and soon reached the outskirts of the state capital. The view from the road above town is breathtaking — the colorfully painted colonial city spreads out ahead while miles of lush, green valley fan out in all directions.

Our next leg of the trip soon found us airborne, taking the short flight to Mexico City. On final approach, we spied Popocatépetl out the window, the second-highest volcano in North America. Just 34 miles distant, it looms over Mexico City and the nearby city of Puebla. Thirty million people live at its mercy. It has been smoldering, threatening and erupting for tens of thousands of years; every so often it swallows climbers who dare to scale its hot and smoky flanks.

We arrived in Mexico City in time for our meetings, the first with painter Roberto López Fuentevilla. He'd joined Novica three days earlier and had already sold five paintings online.

"I didn't have much confidence in the idea of selling my art on the Internet," Roberto commented. "I'd looked into it a bit, and everyone else wanted to charge me a fee to list my work on their site — whether it sold or not, and there was no guarantee that anyone would see it. This time I didn't have anything to lose. I'm amazed by what's happened and I'm enchanted with this system," he said, still looking surprised and baffled by it all.

At age 14, Roberto won his first major art contest and soon thereafter joined the 400 licensed painters who sell their work every weekend in Mexico City's Jardin del Arte. The painters are required to pass a stringent art review before a board of judges prior to setting up shop.

"There are many painters of tremendous quality in the gardens," he said, "but we just don't have the opportunity there that the Internet has suddenly opened up for me now."

Roberto said he dreams of traveling to Europe one day to paint the scenes he's come to love through the cinema — especially Italian cinema. But for now, he added, he's very busy painting scenes from his own country.

"What's happening for me right now is consuming my focus," Roberto explained. "And in Europe, Asia, the United States — wherever they're seeing my art now through Novica, I'm hoping to transmit this feeling, this sentiment of the strong vision I have of my country. I hope people will see my work and gain a greater sense of what is Mexico," he concluded. "Mexico is very rich in all senses, and filled with tremendous color. I paint with the aim that people will actually enter my work and feel what I was feeling, as if they were there. I view each canvas as a window that the viewer should be enticed to walk through. And then they will know that Mexico isn't just about bullfights and cowboys, but a magnificent country of enormous diversity."

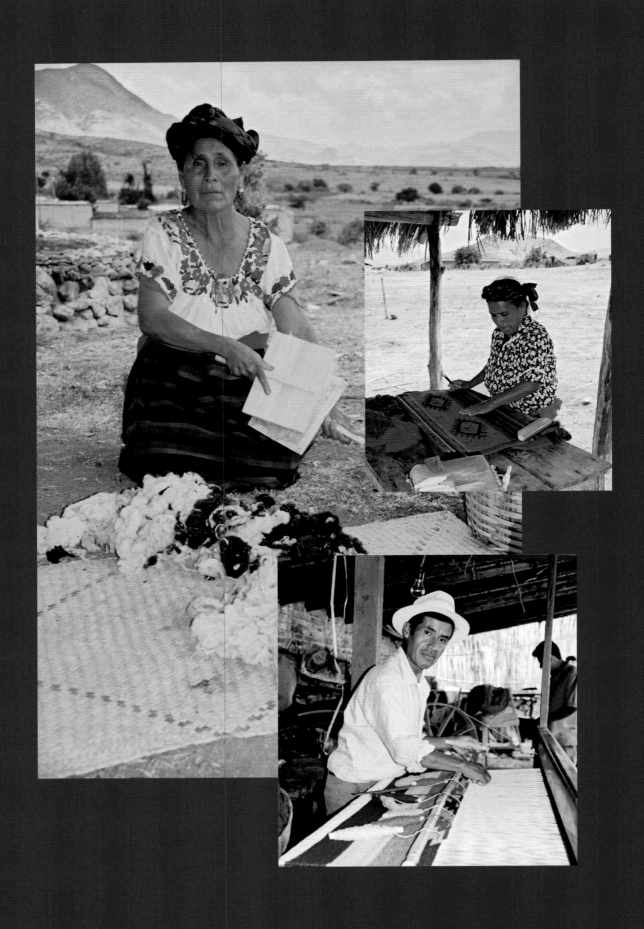

Ruiz Bazan Family

"We are all involved in every aspect of weaving, from washing the raw wool when it arrives at shearing time, to carding it carefully and dyeing it in many beautiful shades before weaving begins."

"Our family has been weaving Zapotec-style rugs for many generations, dedicating ourselves purely to this process. We purchase wool from a farmer nearby and dye it with natural dyes collected from native plants, some of which we find at the morning marketplace. Some of the plant dyes we grow ourselves, including small flowers that contain a very strong pigment.

"We are all involved in every aspect of weaving, from washing the raw wool when it arrives at shearing time, to carding it carefully and dyeing it in many beautiful shades before weaving begins. We are especially careful to choose the right colors for each rug — we put careful consideration into this artistic aspect of the rug-making process.

"Not one of us has ever hesitated to become a rug weaver. We have all grown up watching our parents and grandparents weave, and because it is an enjoyable process, we have followed in our parents' footsteps as adults. During the weekends we teach our children this same art form that has been passed down through many generations. Our children are learning in school that they have opportunities to try other types of work as well, but we would not be surprised if they eventually decide to become rug makers, following the tradition of our ancestors.

"Our rugs carry the lines and colors of our native land. In keeping with the Zapotec tradition of carefully selecting each family member's name, we actually baptize each of our rug designs as if the rugs were born and needed a name with which to be identified. *Ojo de Dios Sobre las Montañas* ("The Eye of God Over The Mountains"), *Piedra del Sol* ("Stone of the Sun"), and *Flor de Oaxaca* ("Flower of Oaxaca") are examples of some of the names we give our rugs."

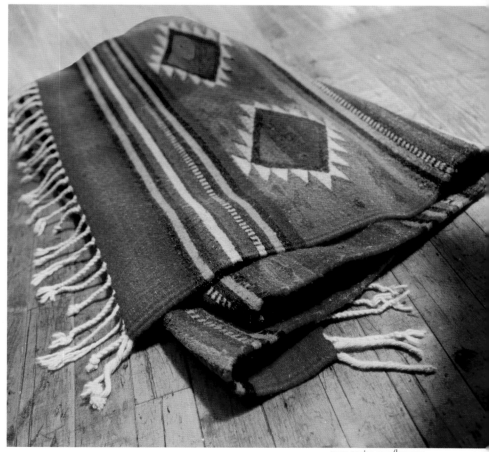

www.novica.com/keepers

75

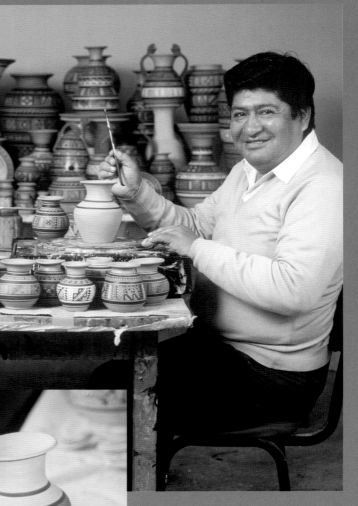

We are so pleased with the two warrior plates we received from the Huaman Paucar family, and are now waiting for another order to arrive. Their workmanship is excellent, and their ceramics will be in our home for years to come.

— Donald Oldenkamp, Iowa

Ubaldina & Gerardo Huaman Vaucar

"Our family's journey in the ceramic arts has been influenced by the customs and lifestyles of our village."

"My wife and I hail from Cuzco, the capital of the Inca Empire, situated deep in the Peruvian Andes. We dress our jars and decorative plates in beautiful designs from ancient Peru. Each carries the powerful, elemental mystery of water and earth.

"Our family's journey in the ceramic arts has been influenced by the customs and lifestyles of our village, a village of ceramic artisans.

"When Ubaldina was young, she attended obligatory classes at the Escuela Artesanal de Pisac, the Artisan School of Pisac. This knowledge of hers inspired us," continues Gerardo, "and awoke in us a passion for ceramic art, a passion that our three grown children share with us. Our production is prolific and varied; we make *keros, aribalos,* plates, vases, jars and other decorative objects, all with diverse Incan motifs.

"Our work is meticulous, and we put forth much effort in the finishing touches — that is the quality that identifies us. In our home-based workshop we also teach other ceramists in our tradition, and many have stayed to work with us.

"Our clay pieces are molded both on an old-fashioned wheel and by hand. Later they are fired in a brick oven that reaches a temperature of 800° to 900° Celsius. After this, we decorate them using varied tones of paints and pigments. In our *artesanía* we represent the history and customs of our village and its religious beliefs."

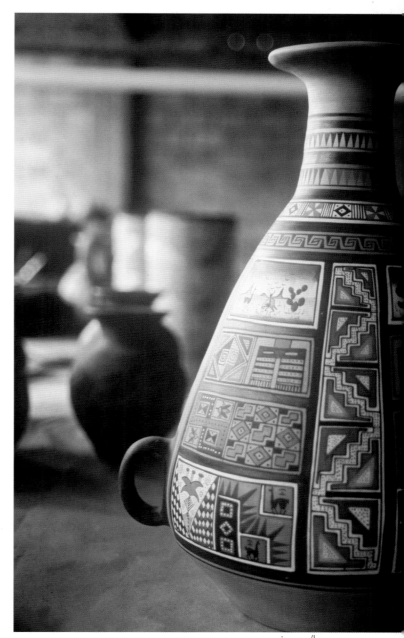

Fidel Barrientos

"Today I serve as the principle furnituremaker at Peru's presidential palace..."

"I learned the art of woodcarving thanks to my relatives, who are also artisans. Today I serve as the principle furnituremaker at Peru's presidential palace, and also teach others the craft that I began to learn when I was 22 years old.

"In the photograph below you will see one of my recent projects, a collection of chairs carefully carved and adorned with ornately hand-tooled leather, sitting in one of the conference rooms of the presidential palace.

"My principal desire is to express the creativity and ingenuity of the Peruvian artisan and the traditions of our culture, so rich in style and design.

"With perseverance and hard work, my style of artistry has now captured the imagination of many people — and I have even earned a number of awards for my work."

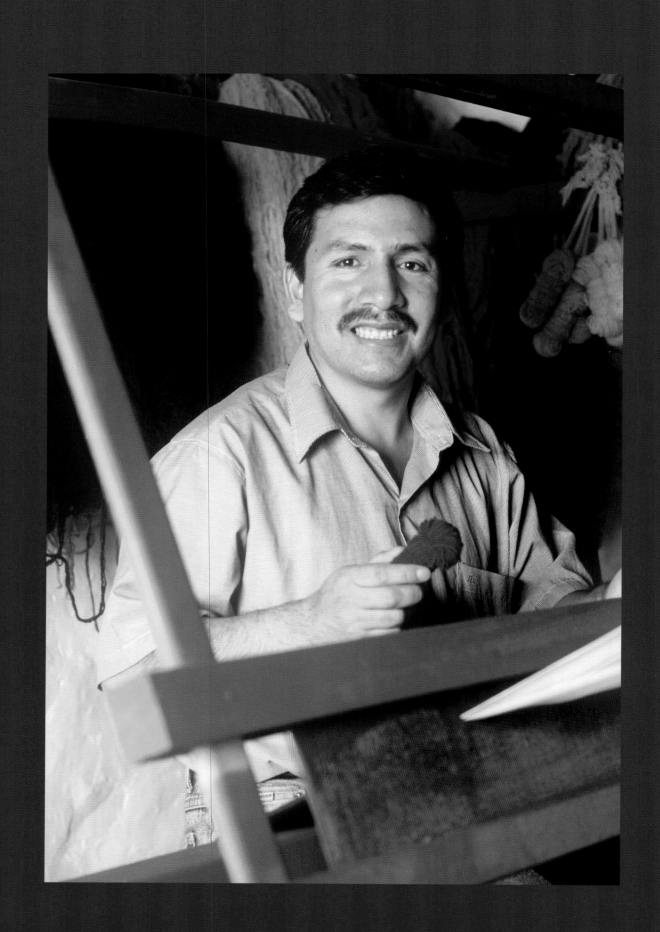

Cerapio Vallejo

"I draw inspiration from our ancient Peruvian cultures, Andean village life, and from our snow-capped mountains."

"My art form was handed down to me from my parents and grandparents. But the quality of my work is the result of my long experience and the product of my careful observation over the years. I draw inspiration from our ancient Peruvian cultures, Andean village life, and from our snow-capped mountains.

"I have faced many challenges during my life, and I have learned from them. Perhaps the most difficult was when I was obliged to leave my house in Ayacucho with my family and emigrate to the capital city. I had to make this painful decision because there was no other way. This was during the 1980s, when terrorism was bleeding my people to death and there seemed little hope.

"Artisans in my region were considerably affected when tourism halted. Even now that Ayacucho is at peace, we remain in Lima; we created a new life here, and are thankful that Ayacucho is flourishing and we can visit it.

"Our sales have expanded greatly since we began working with Novica and I have been able to support some of my compatriots by offering them jobs. Other artisans who used to help me but had to stop working for lack of sales are now able to return to my workshop — thankfully abandoning occupations that did not stimulate their creativity or interests.

"In the future, I hope to have a bigger and better-equipped workshop. But my greatest goal is to continue to educate and guide my children towards fulfillment, knowing that a good destiny must await them. I have three children; for me they represent the continuation of life — and hopefully of art, too."

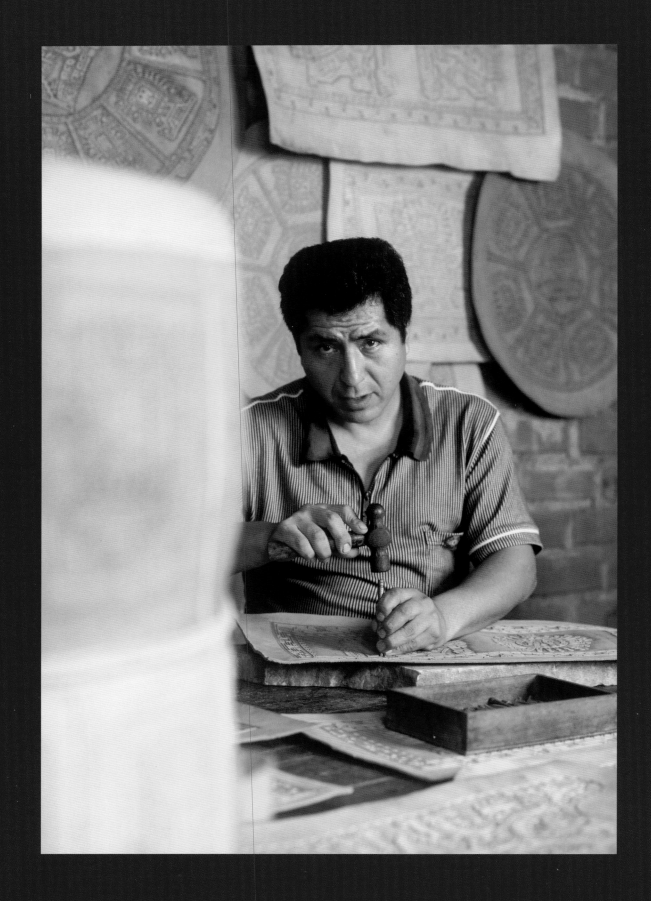

Abel Rios

> *"With my older brother's generous and providential offer, I learned the wondrous art of leatherwork — a trade that continues to fascinate me and consume most of my days."*

"I have dedicated myself to crafting fine leather products since the age of 16. Initially, I began by helping my older brother Héctor in his leather workshop after he asked me to come to work for him. With my older brother's generous and providential offer, I learned the wondrous art of leatherwork — a trade that continues to fascinate me and consume most of my days.

"When I was 23 years old I decided to become an independent artisan. I opened my own workshop in my house. Fortunately, my work has gained considerable popularity, and I greatly enjoy the responses that I continue to receive when people see my creations.

"These days, my work consists of cutting, embossing and engraving fine leather with a distinct style and skill that you won't find in most workshops. I design many beautiful Incan and colonial motifs, and emboss those upon the leather. I sell some of my work locally to art shops, but am especially happy and proud that my products are being sold all over the world now through Novica."

I was most pleased with the magnificent furniture I ordered from Abel. His quality is outstanding; I'm now a fan who checks back from time to time to see what Abel has to offer.

—Michael Dickson,
River Forest, Illinois

www.novica.com/keepers

Absolutely exquisite work. Thank you Asunta.

— Amylane Duncan,
Knoxville, Tennessee

Asunta Velaez Ramos

"My designs are taken from nature, and typical scenes from my town and region. I feel very proud of the works that I create, and I look forward to sharing them with more and more people around the world."

"I have been dedicated to this art form since I was 17 years old. I originally started learning through the influence of my husband's family. In time we united our skills and labor. Little by little, I learned to design and paint. I realized that the more I practiced, the more this craft won me over, offering me tremendous gratification. Now I consider it a way of life, dedicating myself full-time.

"I now create many kinds of beautiful mirrors, coasters, boxes and trays. My tools consist of simple brushes, hammers, nails and glue. For the designs and illustrations, I use India ink to produce the finer details and outlines. Finally, for colors I use tempera paints and *purpurina,* a dye extracted from the madder root.

"I follow a careful process, carefully shaping the wood to give it a pleasing form. Later, for my mirrors, I cut the glass and outline my intended design on the surface with India ink. Next, I fill the outline with beautiful Cajamarcan patterns using paints and *purpurina.* To finish, I glue the glass to the wood and apply a rich golden paint to the borders of the frame. This whole process demands incredible patience and attention to detail.

"My designs are taken from nature, and typical scenes from my town and region. I feel very proud of the works that I create, and I look forward to sharing them with more and more people around the world."

www.novica.com/keepers

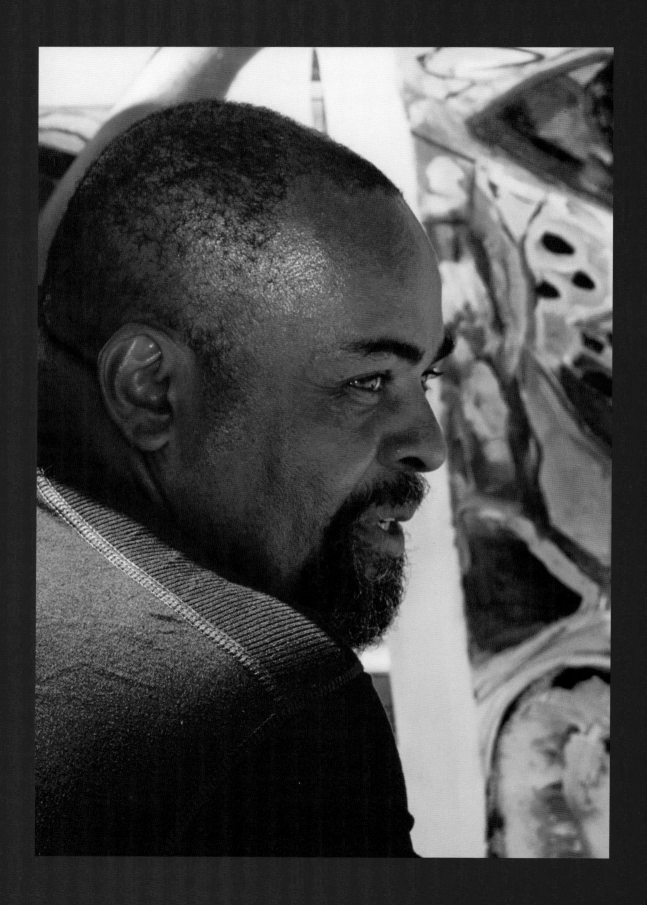

Ney Cardoso

"I have an insatiable desire to paint. My brain yearns to be filled with different ideas and themes...."

"When I was 8, I saw a classmate painting and decided to show him what I had drawn — sketches copied from a comic book. Everyone enjoyed my sketches so much that they didn't believe I'd drawn them myself. This was a good sign to be sure! When I was 17, I entered the Fluminense School of Fine Arts and since then have not stopped drawing and painting.

"I have an insatiable desire to paint. My brain yearns to be filled with different ideas and themes, ideas that usually come from my daily surroundings — from films that I have seen, from paintings that I've particularly enjoyed and books that I've read. There's nothing better than observing people in urban settings. I love traveling to the city and blending in with the multitude of people, observing them as they unknowingly pass by my keen eye.

"Van Gogh, Picasso and Matisse are my huge inspirations. You can notice their Cubist influence in my work. You can also see van Gogh's influence in my use of emotional color. I frequently approach the theme of interpersonal relations, often between women. Women fascinate me with their beauty and mystery. I like to bring this beauty, mystery and interest to my canvases, often rife with human conflict and emotion.

"I am proud and happy to be highlighted in the *Dictionary of Brazilian Artists*, written by the prestigious Brazilian art writers Ayala and João Medeiros, and grateful to Novica for helping me gain international recognition. I work best while listening to music of various genres including classical, rock and Brazilian popular music — especially music by Brazilian artists such as Caetano Veloso, Chico Buarque and Chico César."

www.novica.com/keepers

91

Candida Ferreira

"I like to work during the most silent hours. Before dawn I am already painting. Eventually I realize that the sun has risen and the day has begun."

"My relationship with painting started when I was just a small child. Seeing my interest, my parents regularly bought me canvases, paints and pencils.

"Painting became even more important to me after I got married. My husband Claudio and I moved to Minas Gerais, in the mountains of southeast Brazil. To kill the solitude, I painted while my husband worked. I painted with a very academic style then; today, I paint with freer, unorthodox strokes.

"Learning to paint was a very solitary process for me. I believe that it is necessary to work, to work and to work, and that it is only through learning from errors that we learn to do right.

"I try to represent Brazil in my work by using quite a lot of color. I find inspiration in the images that surround me in my daily life, like magazines and history books. I sit down in front of the canvas and I start to draw, to mix my paints, and little by little a new work appears. It's the best thing in life, an inexplicable sensation. I like to work during the most silent hours. Before dawn I am already painting. Eventually I realize that the sun has risen and the day has begun.

"I am thankful to have had the opportunity to attend some of the most renowned fine-arts schools in the country. I was also fortunate to receive training from the famous artist Fernando Tupper. My paintings have been awarded gold, silver and bronze medals at various expositions."

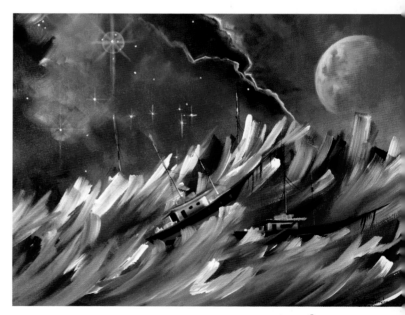

Gerardo de Sousa

"I try to portray the religion of man – the presence of good in each person, no matter what their creed."

"Images of harmony between man and nature have been always present in my work, since the first phase of my painting. Integrating people with trees and rivers set against sunny, dry landscapes. My concern with the environment has always been apparent.

"I want to present a message of peace and fraternity between man and all living beings. I search for The Truth. I try to portray the religion of man — the presence of good in each person, no matter what their creed. Today my urban environment also influences me. I portray many figures of mothers, lovers, and everything that I see in the streets that moves me. Ever since I was a child I have had an enormous desire to create. That creativity began with poetry; today I am a poet of colors.

"I have participated in more exhibitions than I can remember, honestly, and I'm happy to have won several awards in Venezuela, Canada, New York, New Jersey, Geneva and Paris."

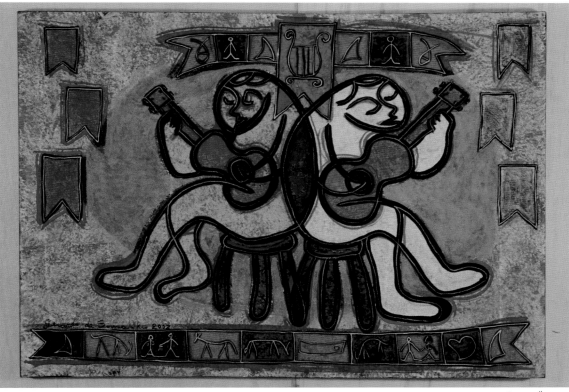

www.novica.com/keepers

Carmen, Thank you so much for your personal note and for the delicate touch you have imparted to the beautiful earrings that I received yesterday. I'll look forward to future treasures from you!

— Arlene Howell,
Houston, Texas

Carmen Cascon

"Brazilian stones fascinate me — the variety and abundance of colors and forms stimulate an artist's creativity."

"I have worked as a jewelry designer for 15 years now. I was a ceramist until I took a jewelry course with renowned jewelry designer Marcio Mattar. As they say, in this moment I passed from the Stone Age to the 'Metal' Age. But I never abandoned my roots. When I create I never design; I feel the stone and give form to a new piece. It is like molding clay. I believe in always mixing the two techniques.

"Brazilian stones fascinate me — the variety and abundance of colors and forms stimulate an artist's creativity. I think that through my work I give value to these little pieces of Brazil. I prefer certain stones: aquamarine, which is very strong and stimulates creativity and communication; pink quartz, which channels the energy of unconditional love (that which everybody needs); and garnet, with which I've had an interesting experience. I was developing a made-to-order collection with garnet. There was a little stone that I decided not to put in the collection; I made a ring with it instead, and began wearing it daily. I felt an enormous surge of energy. Later I discovered that the stone was of my sign, Scorpio. Now I always wear that garnet ring. Since that time, I began to study the energetic properties of every stone, which leaves me even more fascinated every time I create a new piece.

"I have also worked as an art teacher, an activity I began after working with ceramics. It gives me great pleasure to be able to awaken beauty and harmony in people. I believe one of the best ways to do this is through art."

Photographs

Many Thanks

Your patronage has helped change the lives
of many artists and artisans throughout Asia, Africa and Latin America.
We wish to send a worldwide thank you from the Novica Global Team:

BALI & JAVA

Regina Bimadona
Desak Novi Atmoka
I Kadek Agus Tussantika
I Ketut Kusumajaya
I Wayan Roja
I Wayan Sudiartana
Ketut Widiantara
Putu Balik Budika
Putu Perwita Andreani
Rudy Adnyana
Wayan Suprapti

BRAZIL

Hainy Nercessian
Fabio Nercessian de Oliveira
Jane Maria dos Reis Gomes
Lucas Nercessian de Carvalho
Luciana Nercessian de Carvalho
Mariana Leal Rodrigues
Michelle A. Martins de Carvalho
Milene Niza de Sales
Rodrigo Storino

INDIA

Anvita Malhotra
Azmat Khan
Happi Solo
Hawaldar Singh Yadav
Manoj Kumar
Manoj Kumar Chauhan
Meenakshi Gururaj
Nisha Menon
Omveer Singh Pundhir
Paul Gaurav
Rahul Kohli
Sanjay Saxena
Santinder Sandhu
Shivalika Singh
Sunil Kumar Rawat
Tiali Jamir

MEXICO

José Cervantes
Antonio Lucano
Araceli Lopez Suarez
Conchita Santos
Debora Mondellini
Eduardo Ponce
Fabiola Rangel
Isabel Hernandez
Ismael Nuñez Cervantes

Juan Luis Ortiz
Maria de Jesus Jimenez
Noemi Bracamontes
Norma Patricia Ramos
Patricia Robles
Rick Godnick

PERU

Merlly Calisto Cockburn
Carlos Aleman Bejar
Carlos Lama More
Christian Chocano Arevalo
David Estratti
Edith Aylas Zavala
Eduardo Lama Estratti
Fredy Villalta Hurtado
Giovanni Larnia Stratti
Jaime Trelles Garcia
Jose Rojas Gutierrez
Maribel Rodriguez Carrión
Maricela Lama Estratti
Maritza Oscanoa Mendoza
Moises Rivera Cordova
Ruth Chala Castillo

THAILAND

Pornpun Wunna
Alex Avellaneda
Ampai Rungsrisukjit
Anukoon Boonchu
Anuphong Hutawarakorn
Bantawan Chinachai
Chompoo Chaiwong
Ruangphueng Thasri
Rungrat Netepanya
Watchareepron Sangmung
Werayut Nakcharern

WEST AFRICA

Edward Espinoza Humado
Isaac Kofi Kyeremeh
Evelyn Efua Okraku
Gloria Nyarku
Justina Adjorkor Addo
Patrick Kwame Fiagbe
Philip Annor-Asare
Robert Kojo DeGraft Mensah

INTERNATIONAL OPERATIONS

Armenia Nercessian de Oliveira
José Antonio Echeverria
Andre Raw

Cat Anderson
Georgia Patrikios
Pablo La Roche
Raphael Nercessian
Sean Seagrave
Trina Kaufman
Vanda Pignato
Victor Olarte
Vilma Melendez
Yusuke Yamazaki

U.S. HEADQUARTERS

Abril Rodriguez
Alan Paggao
Amanda Miller
Andrew Crocker
Andy Milk
Anne Moore
Antony Reyes
Betsy Kaufman
Bill Gombar
Breeze
Catherine Ryan
Charles Hachtmann-Yang
Chris Floersch
Dan March
Darcy Kries
David Medina
Enrique Rivas
Fran Seegull
Joowon Lee
Lauren Munar
Marcel Honore
Marci Nikitin
Mariana Fraga
Marissa Muñoz
Mark Langos
Mehul Parikh
Michael Burns
Michael Comendador
Michael Mai
Michael Sipes
Milena Nercessian
Nancy Reyes
Patrick Johnson
Pete Burns
Roberto Milk
Sabrina Wong
Sadat Z. Huq
Silvia Cabrera
Steven Klotz
Tina Marie Haley
Vickie Rodriguez

The artists and artisans profiled in *Keepers of the Arts* can be found on a special landing page at www.novica.com/keepers